Watercolor Botanicals

Watercolor Botanicals

Learn to Paint Your Favorite Plants and Florals

EUNICE SUN

LARK
New York

New York

An Imprint of Sterling Publishing Co., Inc.
122 Fifth Avenue
New York, NY 10011

ISBN 978-1-4547-1104-9

Distributed in Canada by Sterling Publishing Co., Inc.
c/o Canadian Manda Group, 664 Annette Street
Toronto, Ontario M6S 2C8, Canada
Distributed in the United Kingdom by GMC Distribution Services
Castle Place, 166 High Street, Lewes, East Sussex BN7 1XU, England
Distributed in Australia by NewSouth Books
University of New South Wales, Sydney, NSW 2052, Australia

For information about custom editions, special sales, and premium and corporate purchases, please contact Sterling Special Sales at 800-805-5489 or specialsales@sterlingpublishing.com.

Manufactured in China

4 6 8 10 9 7 5 3

sterlingpublishing.com/larkcrafts

Cover and interior design by Gina Bonanno
Photography by Christopher Bain
Interior Background Elements: Lyubov Tolstova/Shutterstock, And Akvaartist/Shutterstock, Callie Hegstrom/DesignCuts

CONTENTS

AT FIRST YOU'LL CREATE TO LEARN, THEN YOU'LL LEARN TO CREATE. FOR THE BEST RESULTS, REPEAT THIS OFTEN.

Introduction

WELCOME TO WATERCOLOR BOTANICALS!

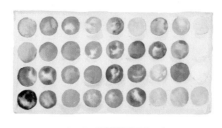

Whether you've never touched a paintbrush in your life or you've been dabbling in watercolors for a while, I'm elated to take you on a journey with my favorite medium! I hope this time you spend with me will be as transformative for you as my watercolor journey has been for me. *Transformative?* you might be wondering. That might not be the first word that you thought when you picked up this book that you bought from a store, found on the handy-dandy Internet, or received as a gift. But I use the word *transformative* because this book will help you see yourself as an artist and allow you to embrace the vulnerability that comes with trying something that takes time and practice.

I fell in love with watercolors in 2015, after taking a modern calligraphy pointed-pen workshop. I signed up for that workshop because, after eight years working full-time in marketing and sales, I felt a creative itch, a space in my brain that I wasn't accessing. I had a desire to explore my creativity. If that sounds like you, let me offer an "I feel you" hug! After I took the class, I started with some terrible pointed-pen lettering and decided that I would commit myself to practicing and actually making whatever this was into something. At the time, I had zero premonitions of where this practice would lead me, but I had committed to a journey. And honestly, that's all it takes to get started.

Eventually, I longed for more color and began playing with brush lettering and watercolors. The moment when I realized that I could blend colors with lettering changed my path forever. I then began painting things that I simply liked and was inspired by daily. Those things included flowers, plants, fashion, food, and more plants. I began developing my unique style, which falls somewhere between realistic and abstract. Those around me and my community on social media began to notice. With my passion for watercolors, I eventually began teaching watercolor workshops, designing for others, and finding more ways to share the art. The colors, the way the fibers of the paper absorb paint, and the infinite blending possibilities of watercolor lit a fire in my heart, and I'm here to light one in yours.

ONE RULE

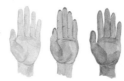

I don't like to follow many rules, but there is one that is nonnegotiable for ensuring that your experience with watercolor will be positive, fluid, and restorative.

Therefore, you will begin with this:

I, _____, will not receive self-deprecating thoughts about my artistic ability. When that little annoying voice comes out, I will take a step back, take a break, and watch my favorite TV show with my preferred snack or beverage, or hug a human or animal. I will then return to my watercolors with the mind-set that learning takes time and creation takes practice. I will remind myself that I am creative, I am able, and I am on my own journey to becoming a watercolor master, pro, or wizard.

HOW THIS BOOK WORKS

In this book, I cover 30 topics that range from basic watercolor techniques to tutorials for painting many types of botanicals. I have curated a collection of 22 different flowers, leaves, and plants for you to paint, and many of these tutorials have a "Botanical Bonus," which includes a lesson that teaches you how to paint a featured plant or flower from a different point of view. Some tutorials also include a project that helps you get more practice on what you learned in the tutorial, and you'll have several combination projects that will allow you to paint different botanicals in one piece. In total, you'll paint 44 different pieces and get to spend so much time with me! (YAY, RIGHT?)

In each tutorial, you'll find the following:

- 🍂 **Color swatches of the paint colors you will need, including paint combinations for when you need to mix colors**
- 🍂 **A list of the supplies you'll need**
- 🍂 **A list of the techniques that you'll be using**
- 🍂 **Line drawings that will allow you to visualize the shapes and forms of the object that you will paint**
- 🍂 **Step-by-step instructions and illustrations to guide you through each tutorial**

THE *Watercolor Botanicals* 30-DAY CHALLENGE

I chose to participate in a 100-day challenge on Instagram back in 2015 when I began practicing pointed-pen calligraphy and lettering. I created a lettered quote every day for 3 months and 10 days, and posted it on my Instagram account. Even though it seemed like I only created one piece a day, the challenge encouraged me to consistently look for inspiration, sit down for at least an hour to draft, and create several versions of a piece until I created *the* one piece I was proud enough to share on social media. By the end of the 100 days, I developed the habit of setting time aside to give myself space to create and—in many instances—create something I had never thought I could make before. It opened my eyes to see daily inspiration everywhere I went. It also allowed me to visually document my progress. It is so valuable for you to see how much you've improved and how much your style changes over time. (You'll see!)

My goal here is to provide you with a structure in which you will set aside time to learn and create for 30 days. That is why I've designed the tutorials so that you can complete each one in one sitting (with additional Botanical Bonus tutorials and projects if you want to go the extra mile). Simply follow along with this book and complete at least one tutorial per day for the next 30 days. Keep all of your work and look back often to see your progress. This, I hope, will lead you to always look for inspiration in your everyday life, establish creative time and space for yourself, and come out at the end with a set of new skills, confidence, and pride in what you just accomplished!

In addition to all my hopes and dreams for you, this book is your opportunity to take a step out of your comfort zone, learn something new, and commit to creating every day for 30 days. This is my personal invitation for you to join me for the 30-Day *Watercolor Botanicals* Challenge! Day 1 begins in the Watercolor Basics chapter (page 21)!

Make It a Social Challenge!

I'd love to invite you to join in on the 30-day #WatercolorBotanicalsChallenge on the social media platform of your choice! You can start anytime: simply complete the tutorials in this book and post a watercolor painting each day with the hashtag #WatercolorBotanicalsChallenge. Do you need to do the challenge consecutively for 30 days? I vote yes, but you can take your time to work through this book—whatever is best for you. Remember, completing a tutorial every day encourages you to develop a creative practice and build your skills. Bringing your challenge to social media will hold you accountable, showcase your work, inspire your friends, and most importantly, plug yourself into the online art community!

Make sure to look through the hashtag to connect with others on their journey, root for each other, and have fun! I guarantee that once you're done with the 30 days, you're going to be surprised, exhilarated, and proud to see how far you've come. You can also follow me on my social media accounts to check for updates and additional challenges that we can complete together.

You were born with the most important tools to create: your heart & mind.

Tools & Materials

You're going to need some things before you start tackling the tutorials in this book. I'm giving you permission to get your shopping on, or, for some of us, a nudge to get out your storage bin(s) of hoarded art materials. There are lots of types and brands to choose from when it comes to paints, brushes, and paper, but I assure you that you won't need much to get started. This section will cover all the tools you'll need to paint through this book, some optional ones that might be helpful to have on hand, and some items that you can invest in later during your watercolor endeavors.

If you've ever done a quick online search of watercolor tools or glanced at what is available at your neighborhood craft or art supply store, you've noticed that generally paints, brushes, and papers are labeled as "artist grade" or "professional grade" and "student grade." My advice is to start with the higher quality student-grade tools and materials, then work your way up to artist-grade supplies when you want to invest more time into watercolor painting.

PAINTS

Watercolor paints consist of powdered pigments mixed with a vehicle, which is the oily liquid contained in the paint. The vehicle is made of several ingredients, including a binder such as gum arabic; additives such as humectants and plasticizers, which keep the paint from hardening; preservatives to prevent mold; and, of course, water. The pigment is suspended in the vehicle so that you can then use a brush to apply the mixture to paper where it will dry and become your final piece. Watercolor paints come in three different forms: tube, pan, and liquid. Their forms define how they are activated or how they are mixed with water to make them ready for use. Depending on the form that you pick, you'll need a different amount of time, effort, and water to prepare your paints for use. Each form has different features and benefits. When shopping, feel free to choose materials that work for you and your budget. I personally utilize all forms of watercolors listed below, but I use tube watercolors the most. No matter what type of watercolors you select, I recommend purchasing a set with at least 12 colors, or even better, 24 colors.

Tube watercolors (A) typically come in metal or plastic tubes and have a paste-like consistency. Tube watercolors are vibrant and only need a little water for activation after you squeeze them out of the tube—about one brush full. Once dry, you can easily reactivate these paints with water; when you're done

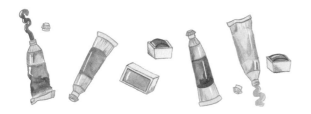

painting, you can simply let your paints dry and save them for the next use, avoiding waste. Tube watercolors are convenient for color mixing, too. Simply squeeze the amount you need from the tube when you want to create a variety of mixed colors and color values (see Color Value, page 27).

You can prepare tube watercolor paints in two ways. First, you can squeeze out the exact amount you need for each sitting on a mixing palette (page 8). But because using a mixing palette can make it hard to estimate the amount you need (and waste is a bad word in my language), I prefer a foldable palette box (page 8) with slots or wells that you can prefill with your tube paints. The foldable box allows you to protect the paints from dust and particles, and then reactivate them with water each time you want to paint.

Pan watercolors (B) are pre-dried paints in small plastic pans. They typically come in sets with a case and built-in mixing palette. To use pan watercolors, you need to use some elbow grease to activate the dried paints by wetting your clean brush with water

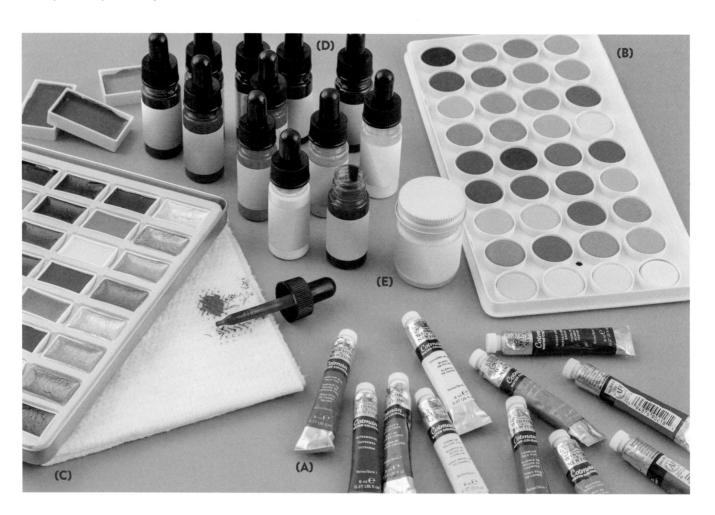

and swirling your brush on the paints to mix them with water. This creates a pigmented liquid with which you paint. That aggressive swirling motion can be hard on your brushes, so take care to not be *too* aggressive when activating the paints. Pan watercolors are a great option for on-the-go painters because the paints are ready when you are—no squeezing needed. They are vibrant and can easily be mixed with other colors using the built-in mixing palette or an external one.

Japanese pan watercolors (known as gansai) (C) are semimoist, creamy pan watercolors that have a shine to them, even before they are activated with water. The difference between Western and Japanese watercolors is that Western watercolors are typically bound with gum arabic, whereas Japanese watercolors are bound with a combination of binders like glue, glycerin, starch, sugar, and beeswax. I personally like using Japanese watercolors because their semimoist consistency makes it easier to activate the paints in their pans and because vibrant colors are easier to achieve in a shorter amount of time.

Liquid watercolors (D) are made from pigments or dyes mixed with a vehicle and pre-diluted in distilled water. Liquid watercolors come with an eyedropper so you can easily drop the desired amount onto a mixing palette and use them without adding water. I love liquid watercolors for intense blending, as the colors out of the bottle are concentrated and bright. When you add water to liquid watercolors, it dilutes the paint and creates lower color values. As with tube paints, you can decide how much liquid watercolor you want to use each time. Liquid watercolors *can* be reactivated, but since they're already made with a significant amount of water, the quality of the reactivated paint is not the same as the paint that comes straight from the bottle.

White watercolor (E) exists in each of the forms described above, but I prefer using white tube watercolors for mixing and creating additional colors. I find that pan and liquid white watercolors tend not to mix as well when creating other colors, because they are not as opaque as tube watercolors. For an even more opaque effect, which is helpful when you're adding details to your pieces, I recommend using an opaque white water-based paint like Dr. Ph. Martin's® Bleedproof White™. This is a must-have for my paint collection, and I use it in almost every project.

BRUSHES

Brushes are your magic wands! There are some types of brushes that are very versatile, while others have been designed to create very specific effects and looks. My advice is to invest in a collection of high-quality brushes in the higher student-grade or lower artist-grade levels. You may not need top-of-the-line professional brushes right away, but having high-quality brushes when you're starting off will make a huge difference in your growth as an artist, provide a better experience, and yield more consistent results when you're painting.

ANATOMY OF A BRUSH

Understanding the anatomy of a brush will be helpful when you're shopping for your brushes. You'll soon start to notice the differences between brush types, lines, and brands.

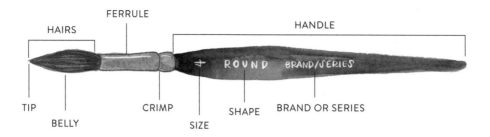

Hairs: The fibers that deliver the water and watercolor mixture to your paper; there are several types of hairs available.

Belly: The middle section of the brush that holds most of your water and paint.

Tip: The very end of the brush where all the hairs come together and feather down to the edge; this part of the brush is commonly used for details and precision in painting and varies based on the shape of the brush. When you buy new brushes, you want to make sure that the brush tips are in good condition and not bent or manipulated.

Ferrule: The metal casing that protects and holds the hairs of your brush.

Crimp: The ridging at the end of the ferrule that clamps the hairs under the ferrule and to the handle.

Handle: The handle is made of varnished wood or plastic and hosts the details of the brush with the size, brand, and series name.

SIZE

Brush sizes range from as small as 00000, which can also be read as 5/0, to as big as 50. Each brush manufacturer may label its brushes differently, but they typically provide measurements in millimeters in the product description that confusingly do not correspond with the number size. For example, a size 2 round brush is 1.6 mm, while a size 14 brush is 8 mm. With so many sizes to choose from, it can be a tad overwhelming to decide what you really need. In general, you should have some brushes in the following three size categories. You'll need small brushes (00000–2) for details, medium brushes (3–8) for general illustration, and large brushes (10–50) for painting washes and larger pieces. Since we're not painting large pieces for the projects in this book, we'll be using a brush from the small category—size 0 round—and a brush from the medium category—a size 4 round.

SHAPE

For everyday use, **round brushes** are the most versatile shape for illustration and for the tutorials in this book. These brushes have a round barrel that can fan open to cover large areas when you apply heavier pressure. When using just the very tip of the brush, you can create extremely fine details. You can paint an entire piece with one round brush, but ideally you'll want to use several brushes for layer painting and fine details. I recommend starting your brush collection off with sizes 0, 2, 4, and 8.

Rigger and liner brushes are also round brushes, but the hairs are thinner and longer, making them well suited for adding details and lines. Since these brushes are longer, they are harder to control, but their biggest benefit is the ability to create more delicate and consistent lines than a round brush can. A good alternative to the rigger and line brush is a short liner. (If you choose to use this type of brush for any tutorial

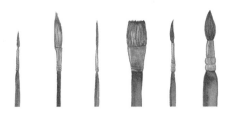

in this book, use a size 0 because it is shorter and easier to control.) If you're looking to add a rigger or line brush to your collection, I recommend a size 1 or 2.

Flat or wash brushes are blunt-cut brushes that are perfect for straight lines and washes. You will choose the sizes for flat or wash brushes based on the size of your pieces. Wash brushes are great for covering a large amount of space in a short amount of time.

There are so many specialized brushes that you can also add to your collection. For example, the **fan brush** is great for creating grasslike strokes, while the **dagger brush** is great for painting things like abstract florals and leaves with its swordlike shape. As you improve your watercolor skills, you can build your brush collection to include many specialty brushes— something to look forward to!

HAIR BRISTLES

Natural hair bristles come from animals such as the kolinsky (a Siberian weasel), sable, squirrel, and camel. They are known for being the gold standard in traditional watercolor painting and have great absorbency, snap (how quickly the bristles return upright after being bent), and fine points. Natural hair bristle brushes are significantly more expensive and are meant to last a lifetime. As you may have guessed, paintbrush manufacturers are very much active in the fur trade.

Synthetic hair bristles are much more affordable, and, with today's technology and vast innovation, are a great match for natural hair bristle brushes. The absorbency, snap, and point quality of synthetic bristles are comparable to those of natural hair bristles; the only drawback is their shorter lifespan, which depends on how often you use your brushes. I paint daily and need new synthetic brushes every 4 to 6 months. I personally prefer synthetic brushes, as I appreciate the price point and the animals spared in the production process!

Blended hair bristles combine both natural and synthetic hair to reap the benefits of both hair types. The price point is less expensive than natural bristles and more expensive than synthetic bristles.

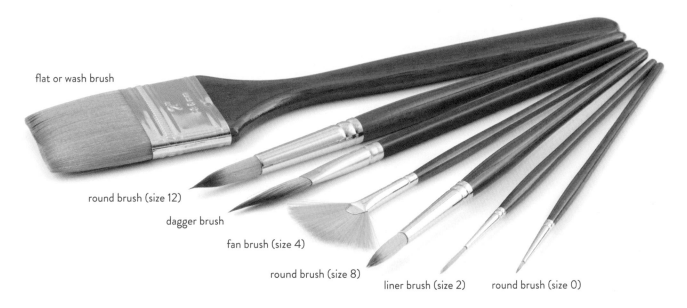

flat or wash brush

round brush (size 12)

dagger brush

fan brush (size 4)

round brush (size 8)

liner brush (size 2) round brush (size 0)

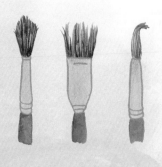

When It's Time for New Brushes

There are a couple of signs that your brushes will give you when they're trying to raise the white flag. The most obvious clues will appear in the hairs of your brush. It's time to retire a brush and bring in a new one if you notice any loss of the brush's original shape; bent, fraying, or spread bristles; a tip that no longer comes to its original fine point; or even a loss of hairs.

PAPER

Watercolor paper comes in different qualities, weights, finishing textures, and forms. They also come at different prices. For beginners, my advice is that any watercolor paper will do. As with your brush collection, you can graduate to higher-quality paper as you advance. Paper quality and weight is typically referenced in pounds per ream (lbs.) or grams per square meter (gsm). In general, I recommend and use acid-free 140 lb. (300 gsm) cold-pressed paper on a daily basis and switch to 300 lb. (640 gsm) paper for special projects that require a lot of layers of water and paint. For the tutorials in this book, I recommend picking up 9 x 12-inch (22.9 x 30.5 cm) watercolor paper pads.

QUALITY

Watercolor paper comes in two qualities: artist grade and student grade. **Artist grade** paper is typically made with 100% cotton (also known as 100% rag) and is acid-free, while **student grade** paper can be made with other ingredients, such as wood pulp. This allows it to be sold for a lower price point. As you can imagine, 100% cotton paper is resilient and can withstand a lot of water and paint because it is more absorbent. It warps less than student-grade paper. That being said, I do want to remind everyone that paper is paper. Artist or student grade, paper will warp if it gets wet, so don't be alarmed when your artist grade paper happens to warp after you apply a heavy amount of water and paint.

Student-grade paper is by no means bad paper. For typical illustration, it will be more than adequate for what you need. When choosing paper, the key is to look for paper that is acid-free, or archival, which allows your work to last a while and prevents the paper from turning yellow and brittle over time. There are plenty of good-quality student-grade watercolor paper lines in the market that are acid-free.

WEIGHT

Standard watercolor paper weights are 90 lb./190 gsm, 140 lb./300 gsm, and 300 lb./640 gsm. The higher the weight, the thicker and more durable the paper will be; 90 lb. paper is the thinnest weight that can still withstand low amounts of water and paint, 140 lb. paper is the most commonly used and can withstand more activity and water, and 300 lb. paper is most durable and will warp the least. Thicker paper doesn't necessarily mean higher quality. You'll want to choose paper thickness based on your project and what you personally prefer.

PAPER PRESSURE

Paper pressure describes the surface texture of the watercolor paper. When you run your fingers over different types of watercolor paper, you'll notice some

are more fibrous or rough, and others are smoother and more fine-toothed. ("Tooth" describes the level of roughness—the more tooth, the rougher the paper, and the less tooth, the smoother.) When you're thinking about texture, imagine the way the fibers of the paper will absorb your paint and what type of look you prefer on your finished piece (smooth and even, or with a visible grain and texture).

Hot-pressed paper is pressed with heated polished rollers and is the smoothest of the three standard watercolor paper textures. The surface is fine-toothed, slick, and less absorbent because paint doesn't have many rough fibers to grab onto. Hot-pressed paper allows for great detail work, clear and consistent lines, and brighter colors, but it is not ideal for many layers of paint. I recommend using hot-pressed watercolor paper for ink and pointed-pen calligraphy or watercolor projects in which you are not planning to paint heavy layers and do not want the grain of the paper to show.

Cold-pressed paper, sometimes referred to as "not paper" because it is not hot-pressed, is pressed with cold cylinders and textured with felt. It is more commonly used in watercolor painting as it has more tooth and a visibly rough surface. Many watercolor artists enjoy cold-pressed paper for the classic finish that it offers; because the paint visibly is absorbed into the textured surface, it offers the chance to easily play with blending, textures, and colors. Cold-pressed is also great for layering paints.

Rough paper is pressed between textured felt that is rougher than the type used for cold-pressed paper. This creates a significantly toothier surface. The dips and fibers of the paper are even more visible and absorbent, so this type of paper is not the most ideal for detail work but great for larger pieces and washes.

FORMATS

You can purchase individual sheets of watercolor paper, but they typically come in large sizes that you'll need to trim for your projects; the same goes for rolls of watercolor paper.

You'll likely prefer purchasing watercolor pads or blocks. Pads are bound at one edge of the paper, while blocks are bound on all sides to keep your paper flat and prevent warping. The paper found in watercolor blocks is essentially "stretched" for you. Watercolor paper pads generally have a lower price point than blocks, which have gone through a more intensive production process before arriving in your hands.

Stretching Watercolor Paper

Stretching watercolor paper is the act of presoaking your paper with a spray bottle or by giving it a water bath, and allowing it to dry flat by taping or stapling it against a board for at least 12 hours . Then, when you paint, the paper will stay flat and avoid warping. I know what you're thinking: do I need to stretch my watercolor paper before painting? The answer is no. I would do so only if you're planning on using a lot of water and painting a full-page piece; therefore, I would reserve stretching for special projects.

ADDITIONAL TOOLS

Here's a collection of tools that I recommend having in your watercolor tool box. I reference using these tools at least once in this book, in addition to your paints, brushes, and paper!

FOLDABLE PALETTE BOX

If you're using tube watercolors, you'll want to use a foldable palette box **(A)** that can close and travel with you wherever you go. Foldable palette boxes come in many sizes and typically have more than 20 paint wells for individual colors and a few larger wells for mixing colors. We'll talk about how to set up your palette box in the next section (page 16). These are very affordable and are usually made from plastic.

MIXING PALETTE

A mixing palette **(B)** is an open dish with wells into which you can squeeze tube paints or drop liquid watercolor. You can also use it simply to mix colors from the paints in your palette box or pan set. These mixing palettes are made from ceramic or thin or thick plastic. I typically wash these after each sitting, since it doesn't close or protect dried paints from dust and particles.

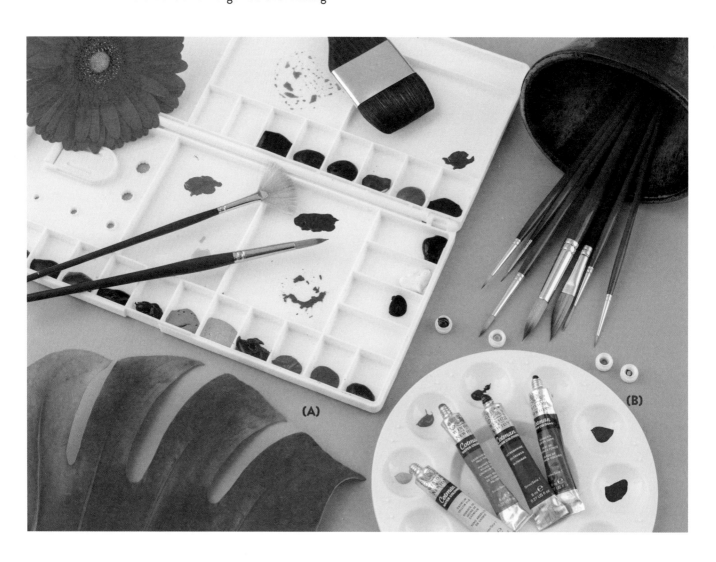

(A)

(B)

PENCIL

We won't be using a ton of pencil in this book, simply because I want you to learn much of what we do by just diving into painting. However, there's nothing wrong with using a pencil, especially for more detailed work or if you want to sketch the line drawings that I provide at the beginning of each tutorial as a guide for painting. Just know that when you use pencil, you need to sketch lightly and as minimally as possible because once you paint over pencil, you won't be able to erase it. Because of this, I prefer to use 0.3 or 0.5 mm lead in a mechanical pencil and a light hand when sketching.

There are H, F, FB, and B pencil lead grades, with the hardest lead being H grade and the softest B grade. Hard lead creates clear, fine lines that are smudge resistant, and soft lead creates smooth, heavy, and easily smudged lines. I prefer the harder lead in the H and F grades because they make fine, clear lines that can still be easily erased. Soft lead can create lots of pencil residue on your paper and your hand, dirtying your papers. Don't sweat the distinction too much. Any pencil will do as long as you're using a light hand and aware that you'll be erasing your pencil as much as possible.

ERASER

There are several types of artist-grade erasers that go beyond the typical pink erasers on the end of your #2 pencils. I personally prefer vinyl or plastic erasers and recommend the pen-style erasers for better control.

I also recommend sand erasers. If you make a mistake when painting, maybe you sneeze and happen to splatter paint on a finished piece (no judgment, happens to me all the time), you can use a sand eraser after using the lifting technique (page 32) to file off the fibers that the paint has soaked into.

CRAFT KNIFE

Let's say you sneezed, splattered paint, lifted paint, sand-erased the blemishes, and there's still evidence of your unwanted paint. The craft knife is the last-resort tool that you'll use to remove the blemish. How? You'll find out on page 34. Hopefully you won't need to use this baby often, but it's good to have one around.

RULER

A 12-inch (30.5 cm) ruler, preferably a clear one so you can see your paper fully at all times, is great to have on hand for sketching straight lines and more.

COMPASS

A compass is not completely necessary, but I know all of you would prefer not to use the lids of a popular scented-candle brand to draw your circles. Dig one out of the bottom of your drawer, or pick one up from the store.

PAPER CUTTER

Cutting paper is something that you'll do frequently so that you can create projects of all sizes. I recommend a sliding paper cutter or trimmer that can cut paper that is at least 12 inches (30.5 cm) at its longest length.

TAPE

Tape will mainly be used to tape off the edges of your pieces so that we can paint over it and peel it off to reveal a clean, crisp border. You can use painter's tape (which comes in multiple sizes) or washi tape, which I recommend as it is a little less sticky and less likely to take the first couple layers of paper with it when you remove it. Most washi tape comes in widths that are a little over a ½ inch (1.3 cm). I recommend painter's tape that is ¾ inch (1.9 cm) wide.

WATER JAR

Since I've started painting, I've begun hoarding glass jars that I use for cleaning my brushes between colors and to hold brushes. I like to have two jars that can hold at least 8 ounces (240 ml) of water, so I don't have to get my lazy butt off of my chair when the water in one jar is dirty. Also, bigger jars are great for holding and storing brushes.

PAPER TOWELS OR CLOTH TOWEL

You'll need something to wipe your brushes when you change paint colors and to absorb excess water in your brushes. You can use paper towels or a cloth towel—it's totally up to you! If you do use a towel, make sure that your towel isn't pilling or else you'll pick up fibers on your brush that you may not notice until after your brush hits your paper.

SPRAY BOTTLE

A spray bottle is convenient for when you want to activate your watercolor pans or dried paint on your palettes. It can also be helpful in cleaning up your desk space after you're done painting . . . or if you get hot and need a refreshing spray of water to the face.

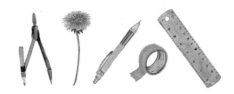

Every morning,
challenge
the world to
inspire you.
THEN, SIMPLY LISTEN.

Preparing to Paint

Let's get you prepped for some watercolor painting! In this section, I'll walk you through setting up your watercolor work space, what you'll need for each painting session, preparing and cleaning your tools, and composition.

YOUR WATERCOLOR WORK SPACE

Maybe your work space is a desk, a dining table, a coffee table, or your kitchen island. Whatever it is, let's talk about how to best set up the place where your watercolor magic will happen!

First things first: Let's talk about lighting. A well-lit area is essential as you want to see the colors of your paint and have a clear vision of what you're creating. I prefer natural light in the daytime, so setting up near a window or where you can get evenly distributed outdoor lighting is best. If you're painting in the evening or an area without windows, it is best to have a desk lamp that sits on the surface of your work area. And remember, the farther the lighting, the dimmer it is. If you're relying on ceiling or recessed lighting, it may not be bright enough and can cast shadows on your work.

Choose a bulb that has cooler lighting (white versus yellow) so that it does not dull your colors or your vision as you paint. Look for keywords, such as "daylight white," when shopping for bulbs and lamps.

Next, let's talk about your sitting situation. Listen, I don't want to sound like your mom, but I can hear my own yelling at me about my sitting posture. When we get into the zone, we tend to hunch over and hold tension in our shoulders, back, and legs. That's why it's so important to choose a chair that has good support and helps you avoid slouching. Choose a chair that works for you; I prefer a cushioned, upright chair with good lumbar support. If you spend a lot of time working on your artwork, there are drafting tables and tabletop easels to help those of us who are ergonomically challenged; they have adjustable inclines so you're not straining your neck down toward your desk. I recommend taking breaks to roll your neck, shoulders, and back, and to stand up to encourage circulation in your legs.

One final note: I am a firm believer in creating a positive and comfortable space physically and mentally for painting, so treat yo'self and grab your drink of choice, turn on a music playlist or podcast that fits your mood, and get comfortable. Treat painting as a chance to unplug, especially if you tend to be hyper-connected all day.

Watercolor Tool Kit

These are the tools and materials needed for all the tutorials and projects in this book. Any additional tools will be specified.

- **Watercolor paints**
- **Watercolor brushes, round, sizes 0 and 4**
- **Watercolor paper, 9 x 12 inches (22.9 x 30.5 cm)**
- **Water jar(s)**
- **Paper towels or towels**
- **Pencil and eraser**
- **Washi or painter's tape**
- **Ruler**

BRUSH HANDLING

Let's talk about the best practices for how to hold, clean, and store your paintbrushes for the best painting results and to elongate your little brushes' lives.

HOLDING YOUR BRUSH

Holding your brush with comfort and control in mind is so important in your painting experience, so don't *brush* it off! Naturally, we all have different ways to hold pens or pencils when we write, but with painting, you'll want to hold the brush like so: With your brush in hand, start with the way you hold your pen when you write **(A)**, loosen your grip **(B)**, and hold it at a more horizontal angle so that it rests back in your hand **(C)**. Have your hand rest back farther than it would when you write; this gives you more room to roll your hand back and forth, allowing you to apply more or less pressure on your brush and create different types of strokes (see Brush Pressure, page 30). As for where to place your hand on the brush, I like to rest the brush's crimp on my middle finger and hold the brush at the beginning

(A)

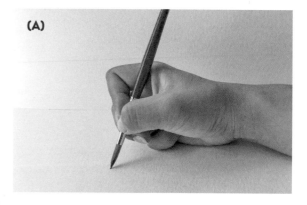

(B)

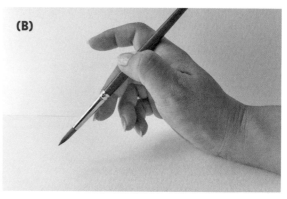

(C)

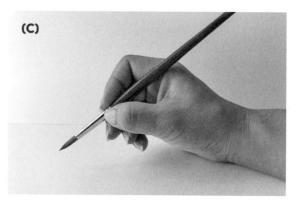

(D)

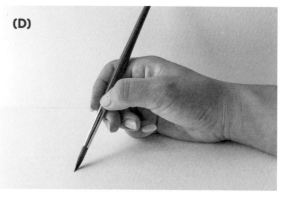

of the handle between my thumb and index finger **(D)**. When I want more control, I will move my hand up the ferrule, with the middle of the ferrule resting on my middle finger and closer to the hairs of the brush. This will allow you to better grip your brush and paint small, precise details.

BRUSH CLEANING

I'll be the first to tell you that after I'm done painting, I often walk away without washing my brushes, and I always regret it! Cleaning your brushes is so important because when paint dries on your brush, it sits on each individual hair and pushes the hairs apart. You'll notice that dry brushes with pointed tips won't retain their shape when they're not clean. I recommend rinsing your brushes after each use.

To clean your brush before changing colors, swirl it in water to rinse off as much paint as possible and then wipe your brush on a towel from left to right and then upward and downward. Repeat this process until your brush is completely clean and does not leave any color on your towel. If you're switching from a dark color to a lighter one, or a cooler color to a warmer one, you'll need a superclean brush—one that does not leave even a slight hue of the last color you used. If your water is dirty and no longer clear, you won't be able to clean your brush completely, so make sure to change your water before you start a new piece or during your painting session. Don't forget to rinse and clean your water jar as well to rid of any excess paint left in the jar. Feel free to use a sponge or toothbrush to scrub your jars with dish soap.

Every few sessions, wash your brushes with a mild soap, such as a gentle dish soap, hand soap, or baby shampoo. Avoid anything labeled as antibacterial as it's meant for hands and considered too harsh for your brushes. Simply run your brushes under the faucet with room-temperature water. Squeeze a dot of soap into the palm of your hand and gently swirl your brushes one by one in the soap. You should see color from the paint on your brush appearing in the soap and suds in your palm. Rinse and wipe your brushes on a towel, and repeat if there is still color coming off your brush.

Always wipe the entire brush dry with a paper towel or towel, from handle to tip, and use the pressure between your fingers to shape the bristle back to its original form. Many brush handles are made from wood and covered in vinyl paint. This means that if you're leaving your brushes wet, the paint will eventually crack under the ferrule. Unless you want naked brush handles, keep those puppies clean and dry after each use!

BRUSH STORAGE

It is imperative to store your brushes correctly to elongate their lifespan. When your brushes are at rest (basically any time they are not in your hand while painting), do not let them sit in your water jar, bristles down. Your brush hairs will bend, and you'll alter the shape of the brush. If you're using a round brush, keeping the pristine point at the tip of the brush is important, and you'll notice the bluntness of the point immediately if you store it improperly. Your best bet is to set your brush on a flat, dry surface when you're not using it.

When you're done painting, cleaning, and drying your brushes, store your brushes in a jar with the handles down and the brush hairs up. Keep this jar out of the sun and away from any excessive heat. Keeping your brushes in a jar is also helpful for keeping them in one place for easy access as you're painting.

If you're traveling with your paintbrushes, make sure to carry them in a hard case that is longer than your longest brush, or a roll-up brush case. It's best to use a case that has slots for each of your brushes to hold them in place and avoid bending or manipulating your brush hairs.

PREPARING YOUR PAINTS

When you begin your watercolor practice, preparing your paints for the first time is definitely one of the most exciting steps. I'll talk about how to prepare and mix tube paints and pan paints, as well as how to clean your paints.

MIXING TUBE PAINTS

As I discussed earlier, you can squeeze fresh paint out of tube watercolors into an open mixing palette, using only the colors that are required for a painting session. I'll do this when I'm working on a specific project where I'll need to test colors or know I'll need a lot of paint. If you're going this route, I always like to start by squeezing out small amounts of paint and then squeezing more as needed to avoid wasting paint. When mixing colors, I squeeze the paints needed next to each other on the palette and mix them together with a wet brush. Start small and add more paint as needed to mix the color of your choice. When you're done painting, rinse the palette under running water to clean it.

If you're going the foldable palette box route, you'll notice that you have smaller paint wells and a few larger ones. The smaller paint wells that line the edges of your palette box are where you'll squeeze paint from your tubes. You'll let them dry and reactivate them here each time you want to paint.

I recommend organizing your tube watercolors by the color wheel, or the order of the colors of the rainbow, starting with red and finishing with white. You

can find my recommended list of colors on page 28. Here is the general order that I prefer:

- 🖌 **Reds**
- 🖌 **Oranges**
- 🖌 **Yellows**
- 🖌 **Browns**
- 🖌 **Greens**
- 🖌 **Blues**
- 🖌 **Purples**
- 🖌 **Grays**
- 🖌 **Blacks**
- 🖌 **Whites**

Once your paints are organized, unscrew each tube one by one and squeeze about a dime-size dollop of paint into each well, working from one side of your palette to the other end. Let your paints dry for your next paint session. To reactivate the paints, moisten the paint wells either with a spray bottle or a wet brush, then swirl your brush to mix the water into the dried paint and create liquid paint. To mix colors, you will load your brush with your paint color and deposit the paint into the larger wells, one color at a time, by swirling your brush into the mixing well. You can also use the edge of the palette to press and pull your brush bristles from base to tip to wring out the brush and deposit the paint into the mixing well.

MIXING PAN PAINTS

The benefit of using watercolor pan paints is that they're ready to go as soon as you unwrap them. Some watercolor pan sets have paper or plastic packaging around every cube of paint, so unwrap each one like it's your birthday and activate it with water from a spray bottle or a wet brush, and you're ready to paint! When you want to mix watercolor pan paints, you'll

load your brush with your chosen colors and bring the paints to the mixing palette space in your pan set or to an external open mixing palette. Keep going back to your pan watercolors to load more paint to your mixing palette as needed.

CLEANING YOUR PAINTS

It's inevitable that over time your paints will get muddied, especially if you're not cleaning your brush in between color changes (which, by the way, happens to all of us!). To clean your paints, you'll need a clean paper towel or towel, brush or spray bottle, and water. Using your brush or spray bottle, apply clean water into your paint palette or paint pan. With a wet brush, mix just enough water into the paint so that the muddied layers are activated. With your paper towel, blot the paint to lift the muddied layers. Continue this until your paint is back to its original hue.

If you're cleaning a mixing palette, or the larger paint wells used for mixing in a folding palette, I like to use a toothbrush to scrub the paint off while rinsing the palette under running water. If you're trying to avoid wells with stored paint, use a spray bottle or fill the mixing wells with water. Scrub and carefully rinse the wells, or wipe them clean with a paper towel. Use mild soap and warm water if your paint is being extra stubborn.

PAINT STORAGE

After each painting session, let your palettes dry before closing them so that wet paint doesn't slide into places you don't want it to go. Store the palettes away from direct sunlight and excessive heat. Do the same with any tubes or jars of paints. For tube paints, make sure you're screwing the caps on completely so the paint at the top of the tube does not dry out. If any excess paint is coming from the tube, transfer it to your palette and wipe the threading of the tube's cap clean with a damp towel so that you can screw the cap back on securely.

PREPARING YOUR PAPER

In addition to knowing what you'll be painting, you'll need to prepare your paper size, border size, and composition before you start. I'll specify what you need to complete for full-page projects in this book, but you can decide what you ultimately want for your future works of art.

SIZE

Watercolor paper can come precut in several different sizes. I recommend having a pad of 9 x 12-inch (23.9 x 30.5 cm) paper on hand for the tutorials in this book, but when you begin to pick different sizes for your own projects, my tip for choosing the right dimensions is to understand where your final piece will be going. If it will go into a frame, look at frame and mat sizes to decide on the size. If it's a spot illustration or a painting that will be digitized, the size of the paper and painting won't matter as much.

BORDERS

Borders are the white space surrounding your artwork. For this book, I will specify which projects require borders and which have illustrations that reach the edges of the paper. If you're looking to display your painting in a specific frame, definitely check the dimensions of the frame and mat board beforehand so you can measure your borders correctly. Borders should be the same width on all sides of your paper. I personally like a ½ inch (1.3 cm) or 1 inch (2.5 cm) for a busy, wide-framed piece, and a 2-inch (5.1 cm) border for something simple or a subject that is centered on the paper. For pieces with a background wash or a piece that will run over the frame of the border, I use washi tape to tape the edges off. Using tape gives you clean, crisp edges. If I'm painting something centered within the borders, I'll use a pencil and ruler to lightly sketch

the edges of my painting and erase them when the piece is done.

COMPOSITION

After you've decided what you're painting, the size of paper, and the thickness of border, you want to settle on the placement of your subject (or subjects). The organization and mapping of the elements in your piece, whether they will be centered on your paper, scattered throughout your piece, or take up a full page, is called composition. To create visually interesting composition, you'll first need to decide what the focus of your piece is and what you want your viewers to connect with first.

RULE OF THIRDS

The rule of thirds is a great guide to creating pleasing composition. To use this rule, you will divide your paper into thirds using two equally spaced vertical lines and two equally spaced horizontal lines. This creates three equal-size rows and columns, and nine spaces.

The idea behind the rule of thirds is to place the key features in your piece along the four lines and the intersection points of these lines (the corners of the inner rectangle created by the intersecting lines), which are the main focal points of the piece. They will draw the viewer's eye. Placing your elements using the rule of thirds help you avoid "breaking" the piece into two by placing something right in the center, although I do like to use the guidlines to do just that, as they indicate where the exact center of your piece will be.

Here is an example of how to use the rule of thirds. This Palm Springs–inspired landscape shows a scene in front of a mountain, with four palm trees and a bicycle. Looking at the horizontal rows, you have the sky and palm trees in the top third of your grid; the mountain in the middle third; and the wall, sidewalk, and bike in the bottom third. Looking at the vertical rows, you have two out of four palm trees sitting along the two vertical

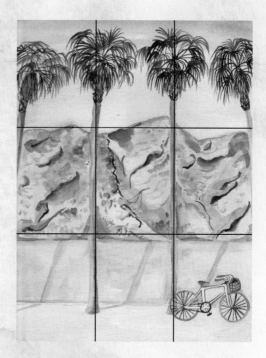

lines of the grid, and you have the cute little bicycle parked in the bottom of the right column. Your eyes should be drawn to the mountain on the horizon, the palm trees, and the pop of the pink wall.

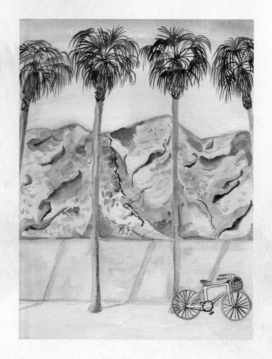

Here is an example of an intentionally centered piece. I love the use of negative space (white or empty space) around a small centered subject, so even though the rule of thirds is meant to avoid this composition, you can use the grid to create a simple, centered painting like this one featuring a bunch of ranunculus.

RULE OF ODDS

The rule of odds is the concept that subjects appearing in odd numbers are more pleasing to the viewer's eye. When you're creating a piece and have the freedom to choose the number of subjects featured in your piece, stick to three, five, seven, and so on subjects. In this example, we see a set of three red anemones. This piece also follows the rule of thirds.

Don't worry if this is confusing right now. It will make sense over time as you become more comfortable with painting full pieces. There are a few projects in this book that will allow you to practice composition, so refer back to this section if you get stuck.

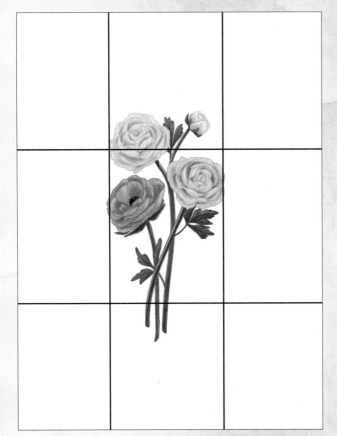

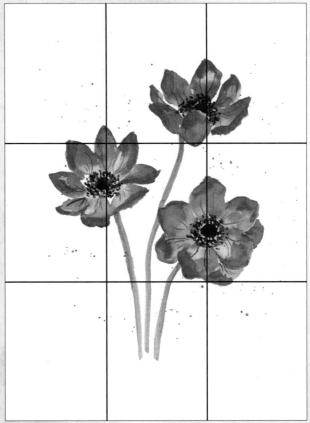

THIS IS WHERE THE FUN, COLORFUL STUFF HAPPENS.

Watercolor Basics

*N*ow that we're prepared to paint and ready to go, let's dive into the nitty-gritty of watercolor basics! In the next three chapters, we'll cover color theory, which will help us understand how to use color; painting techniques, which will arm us with how to use all of our tools; and layers and details, which will help make our watercolor paintings come to life.

Day 1: COLOR THEORY

To best understand how to use and mix your colors, let's start with the basics of color theory. Color theory, created by Sir Isaac Newton, is a set of guidelines for mixing colors and identifying the visual effects of color combinations. It is a great place to start when you're engaging in any pigment-related art that requires you to get creative with making colors using ones that you already have. We're going to start your first project here, so get comfortable in your watercolor work space with your favorite leisurely drink and your Watercolor Tool Kit (page 14). We'll be using just a size 4 round brush for this section's projects.

Let's go back to the time when you were just a wee little one and spent your time with art projects, animal identification, simple math, *and* an afternoon nap. (Those were definitely the days!) Bring back what you learned about **primary colors**: red, blue, and yellow. You can create any color visible to the human eye by using combinations of just those three colors. (That's why they're called primary colors!)

When two of these colors are mixed together, you will create three additional colors called **secondary colors**.

Red + blue = purple
Blue + yellow = green
Yellow + red = orange

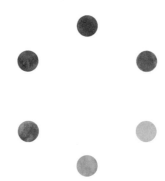

From here, you make **tertiary colors** by mixing one of the three secondary colors with a primary color.

Red + orange = red orange
Red + purple = red purple
Blue + purple = blue purple
Blue + green = blue green
Yellow + green = yellow green
Yellow + orange = yellow orange

Note: If you need brown paint, you can mix equal amounts of all three primary colors together to create it. Brown is a composite color. A composite color is one that is created by mixing primary colors; using different proportions of the primary colors creates several different colors. Brown is not part of the basic color wheel, although it can technically appear as a darker shade of orange.

PROJECT: Color Wheel

The color wheel is a visual representation of colors and their relationships with each other. Understanding the color wheel will be helpful in mixing colors and choosing color palettes. With this project, you'll see how the color wheel grows from three primary colors to a total of 12 colors. You can use a compass or trace a circular object to prepare your color wheel.

What You Need

Watercolor Tool Kit (page 14)
Compass (optional)

1. Find the very center of your paper and, with your compass, draw a circle with a 5-inch (12.7 cm) diameter by placing the needle on the center point of your paper.

2. With your pencil, lightly make marks on the outline of your circle where the numbers 1 through 12 sit on a clockface. Start with marks at the top and bottom center of your circle for 12 and 6 o'clock, then 3 and 9 o'clock, and continue to add each number between 1 and 11. Then, paint a red circle at 12, yellow at 5, and blue at 8.

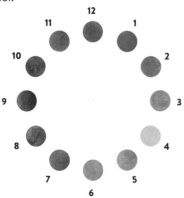

3. Mix your paints to create secondary colors with the color equations left, and paint circles in the following spots: orange at 2, green at 6, and purple at 10.

4. Mix your paints to create tertiary colors and paint circles in the following spots: red orange at 1, yellow orange at 3, yellow green at 5, blue green at 7, blue purple at 9, and red purple at 11.

BASIC COLOR SCHEMES

Color schemes are color combinations used to invoke specific feelings, express a particular style, and appeal to the viewer. Color schemes can range from different shades of one color to combinations of multiple colors, and they can be formulated by following the color scheme guidelines discussed in this section. We'll dive into different color schemes by starting with the distinction between warm and cool colors.

Take a look at the color wheel and see if you can pick out the **warm colors** and **cool colors**. As their names suggest, warm colors reflect the colors of heat, such as yellow, red, and orange. They make you feel cozy, intimate, and content. Cool colors reflect the colors of

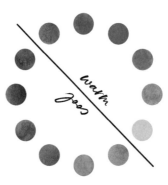

a cold, overcast day, such as blues, purples, and greens. They make you feel calm, invigorated, and refreshed. When choosing a color palette, think of what feelings you want to evoke, and don't be afraid to use both cool and warm colors in a single piece, as the combination of the two can be very pleasing to the eye.

The next step in choosing colors that will work together is simply defining **complementary colors.** Complementary colors sit directly across from each other on the color wheel. Imagine how your crush in high school always managed to be in your direct view— straight ahead—those dreamy eyes. And in the world of color, opposites attract! Complementary colors are two colors that highly contrast with each other: red and green, yellow and purple, and blue and orange. When they are used in the same piece, they are impactful to the eye and draw the viewer into the painting. Plus, when two complementary colors are mixed together, they create the same color gray. In traditional painting, complementary colors are used sparingly, but you're the artist here, so the color world is your oyster!

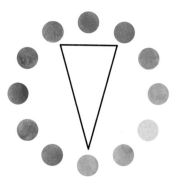

Analogous colors are three colors that sit next to each other on the color wheel. This is a nice option when you're looking for a uniform feel throughout your painting and low-contrast blending where your colors are not drastically different from each other. With analogous colors, it is best to avoid mixing warm and cool colors, but like I said, you do you!

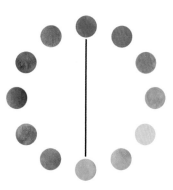

A subtler way of using complementary colors is to choose a **split complementary** color scheme. Instead of picking the color directly across, you use the two colors surrounding the complementary color for a softer and possibly more harmonious combination. For example, one common way to create a pleasing color palette is to select one warm color and use its two split complementary colors to highlight it, or vice versa.

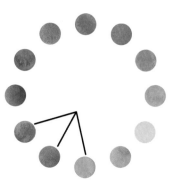

Triadic colors are three colors that are equally spaced on the color wheel. (In our case, our triadic colors would be spaced three colors apart.) Like complementary colors, triadic colors are high contrast, but they are more harmonious and balanced. With triadic color schemes, the key is to choose one main color and use the other two in supporting roles and in small doses throughout your painting.

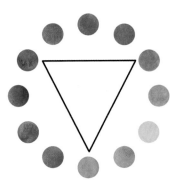

Lastly, we have **tetradic colors**, which contain two sets of complementary colors. This type of color scheme is the most vibrant and rich because complementary colors are already so high contrast, and with tetradic colors, you're pairing two together. Again, the key with tetradic color schemes is to choose one dominant color and use the others in small amounts.

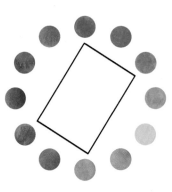

CHOOSING YOUR COLOR PALETTES

Whew! We just went over quite a bit of technical information about color, but before you become too intimidated, I highly recommend taking some time to practice putting together color combinations by taking what we learned here and simply swatching colors, which involves quickly painting colors next to each other and even overlapping them to see the combinations and color blends. Choose combinations that group well together and are pleasing to your eye—*you* are the artist. I spend a couple minutes before starting each project doing this and now you have the basic foundation of color theory to do the same!

COLOR PROPERTIES

Color consists of three qualities: hue, color saturation, and color value. Understanding the differences of each will be key in identifying colors you want to use while you paint as well as mixing them.

HUE

What's a hue? You just learned what it is simply by learning about color theory and the color wheel. A **hue** can be thought of as any pure color from the color wheel, including primary, secondary, tertiary colors, and beyond. A hue is considered pure because it does not contain white, black, or gray.

COLOR SATURATION

Understanding color saturation will make a huge difference as you mix paint and create the colors needed for each project in this book and your work in general. Color saturation describes the purity of a color and its relationship to light or brightness. A color that is fully saturated is a color that is at its purest and brightest. The simplest way to think of this is that the hue is the color, while color saturation is the intensity of the color. There are three ways to manipulate the color saturation of a hue.

Tint: Tint refers to a mixture of white paint and a hue. Tints will always be lighter than your original color. For example, if you need a light red or pink, you will start with a primary red, mix in white, and keep adding white until you achieve the desired tint. The more white that you add, the lighter the tint will be.

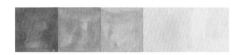

Shade: The opposite of tint, shade refers to a mixture of black paint and a hue. If you want to achieve a dark red or maroon, for example, you will start with a primary red, mix in black, and keep adding black until you achieve the shade that you're looking for. You guessed it—the more black paint you're using, the darker your shade of color.

Tone: Tone refers to a mixture of black paint, white paint, and your hue. When combined, black and white create gray. With the addition of gray to your hue, you achieve a softer color. An example of tone is mixing your red with black and white to achieve a dusty red.

PROJECT: Color Saturation Chart

Let's get started on part two of this chapter's project. We'll be experimenting and creating a chart with levels of tint, shade, and tone of the color red. I'll have you sketch out three separate grids with five squares side by side, so you can easily see the differences between each level of saturation.

What You Need

Watercolor Tool Kit (page 14)

1. Using your ruler and pencil, draw three 5 x 1-inch (12.7 x 2.5 cm) rectangles. Divide the rectangle into four sections by placing four vertical lines spaced 1 inch (2.5 cm) apart. This will create a grid with five 1 x 1-inch (2.5 x 2.5 cm) squares.

2. For your first grid, let's experiment with tints. Activate the red paint with water and paint the first square with this red hue.

3. In your mixing palette, scoop up a small amount of white paint with the tip of your brush. Mix the white with your red hue in your mixing palette. Paint your second square with this tint.

4. Repeat step 3 for the remaining squares in your grid, adding more white each time you

paint a new square. When needed, add more water to keep the paints activated. You should see your red paint become progressively lighter as you move farther down the grid. In theory, you could continue this chart by adding more white to your paint mixture until the red hue is not visible and the paint is totally white.

5. In the next grid, repeat steps 1–4 to create a grid for shades, gradually adding more black paint to your red hue. You should see a significant darkening from the second to third box. If you expanded this grid and continued this process, your paint would become completely black.

6. Using the third grid, repeat steps 1–4 to create a grid for tones, but this time, start by mixing a gray on your palette using equal amounts of black and white paints. Begin to add this gray to your red hue to create your tones.

COLOR VALUE

Color value refers to the lightness or darkness of color. Whereas saturation describes the actual attributes of a color, color value in the watercolor world is determined by the ratio between the amount of water and the amount of paint that you have mixed together. Since you'll typically be painting on white or off-white paper, think of transparency in terms of the visibility of your paper under your colored paint. Less water and more paint will create a darker color value, meaning that your paint is nearly opaque, while more water and less paint will create a lighter color value, meaning that your paint is very transparent.

 Note: Create your own color value grid by following the instructions for Color Saturation Chart on page 26. Instead of adding more paint when painting each square, add more water without picking up paint.

To decide whether I should manipulate my colors by adjusting color value or color saturation, I consider the amount of transparency that I want in my painting. Here's a painting that features an example of both adjustments.

For the sky, I started with a primary blue, lightened it with white to utilize tint and create light blue, and then added water to create a lighter color value and some transparency.For the pinks, yellows, and oranges of the sunset, I wanted to use the colors at their brightest hues, so I did not add white, black, or gray paint. I simply added water and chose the color values that matched the sunset blend I was looking for.

Once I moved down to the ocean, I created a dark blue. I started with blue, utilized tone by adding black paint, and then gradually added more water to lighten the color value for the parts of the ocean in the foreground.

Colors and Paints in This Book

As mentioned in the Tools & Materials chapter (page 1), you can choose from a variety of watercolor paints. Luckily, colors are a universal language. I've written out how I will reference specific paint colors and color combinations. No matter what brand you have, this list will allow you to be able to mix and create colors using basic paint colors or specific premade paint colors.

There is one thing to note about paint color names. As you know, watercolor paint is made with pigment, a colored powder that creates the color of the paint. There are standard pigments used to create paint, like Pigment Blue 29, which is commonly known as ultramarine. There are single pigment paints, which are typically professional-level paints. When you see "hue" in the name of a paint, the paint is made from a mix of cheaper pigments or with less pigment and more filler to make the paint more affordable. Many student-grade paints may have "hue" in the names.

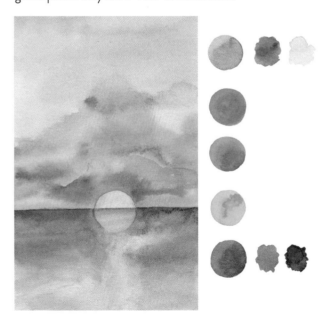

COMMON NAMES FOR PAINT COLORS

Paint Name	Color	
sap green	yellow green	
viridian hue	green	
Hooker's green dark	pale dark green	
Hooker's green light	pale green	
cerulean blue hue	light blue	
ultramarine	bright blue	
indigo	dark blue	
cadmium yellow hue	bright yellow	
yellow ochre	mustard yellow	
permanent rose	deep pink	
dioxazine purple	purple	
rose madder hue	red	
cadmium red pale hue	red orange	
cadmium red deep hue	dark red	
burnt umber	brown	
ivory black	black	
Chinese white	white for mixing tints	
opaque white	white for painting details	

COMMON PAINT COMBINATIONS

Final Color	Colors to Mix	
dark green	viridian hue + black	
blue green	ultramarine + viridian hue	
dark blue green	ultramarine + viridian hue + black	
peach	cadmium red pale hue + white	
ivory	burnt umber + white + a touch of permanent rose	
pink	permanent rose + white	
fuchsia	cadmium red deep hue + permanent rose + a touch of dioxazine purple	

PAINTING WHITE

Before closing up the color section, let's talk about creating white with watercolor. In traditional watercolor painting, the idea is to always work from light to dark color values, because it's easier to darken a previous layer than it is to lighten a layer of paint; the exception to this is pulling up or erasing color (we'll touch on this on page 34).

Because we usually work from light to darks, you create white using the negative space of your painting, leaving the white of your watercolor paper visible in the areas where you want white. In other words, don't paint an area that needs to be white; leave that area untouched, as I did with the holes in the monstera leaf painting on this page.

Since I'm not always a traditional gal, I'm going to throw a wrench in what you just learned. We have something called white paint. Once labeled off-limits by the historical and traditional rules of watercolor, white paint has opened the doors to new realms of color (remember tinting on page 25?) and has allowed painters to add wonderful details that pop off the page. Though nothing can mimic the clarity and purity of untouched white paper, you can use white paint to create highlights (the effect of light hitting an object). For the projects of this book, you will also use it to paint wet-on-dry details (page 32) on your botanicals, such as fine lines and dots.

Day 2: PAINTING TECHNIQUES

It is important that we learn the different ways we can use our brushes to create the effects that we hope to achieve in our paintings. In this section, we will walk through the pressure levels and types of brushstrokes used specifically with the round brush. You can duplicate the same techniques with any other brush.

BRUSH PRESSURE

Brush pressure is as straightforward as it sounds. It's the amount of pressure you're putting on your brush, which creates brushstrokes in different sizes. You'll be able to decide how much pressure you should be using based on what you are painting and how detailed it needs to be.

Brush pressure makes the round brush one of the most versatile brushes—you can create so many different strokes just by varying the pressure.

LIGHT PRESSURE

You will often use very little to no pressure to paint details and thin lines. When using light pressure with a round brush, you will be painting with just the very tip of the brush. Make sure the belly of your brush is not touching the paper—the brush hairs should not be spreading apart or fanning open.

MEDIUM PRESSURE

With medium pressure, you'll press down on your brush so that about half of the brush's belly touches the paper. This creates a thicker line or strip of paint. You'll notice the hairs on your brush fanning open just a bit.

HEAVY PRESSURE

When you put full pressure on your brush, the entire brush belly (from the tip to the base of the brush hairs) should be touching the paper. As you pull the brush across the paper, the pressure will create the thickest line. Your brush should be fanned completely open, and the bristles will be at their widest reach.

COMBINATION PRESSURE

Very often throughout this book, you'll be combining all three pressure levels into one brushstroke to create the shapes of petals, leaves, and other features in your paintings. We'll cover how to do that in the next section.

BRUSHSTROKES AND SHAPES

When it comes to painting botanicals like the Icelandic poppy (page 93), prickly pear cactus (page 118), and monstera leaf (page 102), you'll notice that there are a lot of lines and shapes going on in each illustration. To paint the forms and details of the botanicals in this book, we'll need to get on the same page when it comes to shapes, curves, and types of lines or brushstrokes that we're going to use. Don't worry—it's all pretty simple.

C CURVE

The C and backward C curves look like the two halves of a circle that has been cut in half vertically. In most

instances in this book, I'll be asking you to paint "loose" or "slight" C and backward C curves. Remember, we're painting nature here, so we don't need every stroke to be perfect; I'm just giving you a little guidance to follow as we paint.

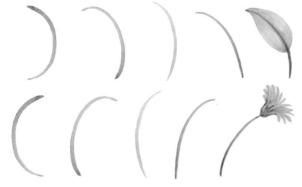

Downward and upward C curves resemble the shapes of a circle that has been cut in half horizontally. The downward C curve has its curve facing up and its opening facing down, while the upward curve has its curve facing down and its opening facing up.

S CURVE

The S curve looks exactly as it sounds—like the letter *S*. I'll often ask you to paint loose S curves and backward S curves (which look like a backward letter *S*) throughout this book. You'll often see the S curve when you paint contour details of your leaves, and on petals and leaves that curl outward, like the petals of the peony (page 79).

COMBINATION STROKE

As mentioned, we'll combine brushstroke pressure levels in one stroke very often. I'll often refer to it as the combination, or combo, stroke. Here's how to paint a combo stroke: Start with the very tip of your brush (light pressure) and pull your brush across the paper, gradually adding more pressure to apply medium and then heavy pressure. Slowly reduce your pressure back to medium, and then lift the brush to finish the brushstroke using just the tip of your brush. Your stroke should resemble an elongated leaf shape. Do you notice that the color value also changes as pressure level changes? This happens because brush pressure affects the way your brush releases paint. When you start a combo stroke with light pressure, there is more water and paint on your brush so the color value is darker; if you apply more pressure, the bristles fan open and spread paint across more space, delivering a lighter color value. The paint will gradually darken as you lift your brush to finish your combo stroke.

Boomerang Stroke

Another commonly used stroke throughout this book will be the curved combination stroke; I call this a boomerang stroke. Start with a combo stroke by using the tip of your brush. As you gradually apply more pressure, begin curving your stroke and create a rounded corner, then gradually lift your brush back up to reduce the pressure until you're using just the tip of your brush.

PROJECT: Abstract Leaf

Let's practice painting a quick abstract leaf that you can use throughout your artwork. You can paint abstract leaves with a single combo stroke to create a straight leaf, or use a single boomerang to create a curved leaf. As you can imagine, the bigger your brush, the bigger your strokes—or in this case, leaves—will be.

You can create a larger, wider leaf with two combo strokes. Begin with the top half of your abstract leaf, and paint a short combo stroke that begins with light pressure and moves to using heavy pressure as you move your brush from left to right. Then, paint an additional combination stroke under the top half of your leaf. You can leave a tiny bit of negative space to represent the center vein (the middle line) of the leaf. Also try this with boomerang strokes for looser, playful leaves.

BASIC WATERCOLOR PAINTING TECHNIQUES

Here are the techniques that you will use every time you pick up your paintbrush. Now that we've learned about color theory and brushstroke techniques, we'll dive into the ways we can use what we've learned to practice different painting techniques.

WET ON DRY

Painting **wet on dry** simply means applying wet paint on either a dry piece of blank paper or onto dried paint. This technique is important when you want defined lines or crisp edges and to avoid blurring or blending. It's especially useful for painting the details of an illustration, like the veins of a leaf. Using watercolors is all about painting in layers, so the wet-on-dry technique is important for the instances when you want to clearly distinguish the different layers of paint.

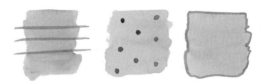

WET ON WET

When you paint **wet on wet**, you're simply applying wet paint on top of a layer of wet paint or clean water, aka blending—my favorite characteristic of watercolors!

Watercolors are defined and controlled by water, so when you're putting a layer of paint over an already wet layer, your second layer will diffuse into the first, creating a unique effect each time. Whenever you plan on painting with the wet-on-wet technique, make sure to activate and mix all of your paints with water before you begin so that you can switch between paints quickly while your previous layer of paint is still wet.

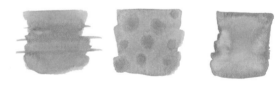

LIFTING PAINT

Lifting paint is the watercolor version of erasing. It can work with both the wet-on-wet and wet-on-dry techniques. In each case, you'll use a dry brush to press down and lift paint off the paper. (Perhaps you've used a similar technique to clean up spilled wine on carpet.)

The key to lifting paint is that the layer being lifted needs to be wet. If it's already dry, add a wet layer of clean water over the area you'd like to lift or erase. Press a dry brush down into the wet layer, and the brush will absorb the paint. You will likely have

to dry your brush on your paper towel between dabs and repeat the motion to achieve the lightness you're looking for.

You might need to lift paint in the following situations: if you want to lighten a color value that is too dark and you have no space in which to pull the paint (see Pulling Paint, page 34), if you're creating a highlight (more about this on page 40), or if you simply need to correct a mistake.

Lifting while wet Lifting while dry

PROJECT: Put the Paint to Practice

Now, it's your turn to see the previous painting techniques in action. We'll be painting squares and putting the wet-on-dry, wet-on-wet, and lifting-paint practices to work. Feel free to try this a couple of times to get really comfortable, because you'll be using these techniques frequently. You can use scratch watercolor paper for this exercise.

1. **Wet on Dry:** Paint three loose squares in any color. Let them dry. Choose a second color, preferably one that is drastically different or has high contrast from the first (perhaps a complementary color), so you can see it. With this second color, paint the following details:

> 🖌 **lines in the first square**
>
> 🖌 **dots in the second square**
>
> 🖌 **outline around the third square**

Notice how defined these details are when you paint wet on dry.

2. **Wet on Wet:** Repeat step 1, but paint one square at a time and add the second layer of paint details immediately after you paint the square so that you can practice the wet-on-wet technique. Notice the huge difference here! You should be able to see the second layer of paint bleed into the first wet layer. The lines are no longer as defined and crisp. If there isn't any blending, that means your first layer either wasn't wet or your second layer wasn't painted with enough water, or both.

3. To try my favorite way of demonstrating wet-on-wet blending, paint a loose square with clean water. Quickly load your brush, line the top of your square with paint, and tilt your paper so that the paint rolls down into the rest of the square.

You should see the color explode into the square and notice the fibers of the paper absorbing the paint.

4. **Lifting Paint:** To practice this technique, paint two loose squares using any color of your choice. Let your first square dry. With your second square still wet, use a dry brush and heavy pressure to pull your brush in the center of your wet square from the top to bottom. Repeat a couple of times, cleaning your brush on your paper towel after each lifting stroke to see how much paint you can remove.

5. Once the other square is dry, add a few thin layers of water to the center of the rectangle. Dry your brush, press the center of the rectangle, and lift your color using the same motion described in step 4. As you can tell, when you're lifting on a wet layer, the lines of your "erased" area are less defined and still a little blended into the original layer. When you lift paint from a dry layer, it's more defined. This exercise allows you to see what either will look like in the instance that you are

able to lift while your previous layer is still wet, or if you don't decide to lift until later on in your painting process, what it looks like to lift on dry.

PULLING PAINT

Pulling paint is a technique that allows you to take the paint that is already on your paper and spread it over a larger area. When there is enough or even an excess of wet paint that you've already put down (perhaps it's a small puddle), you can put your brush down, overlapping where you left off to grab and pull the paint in the direction you'd like it to go. This works in place of reloading your brush with paint and allows you to paint even washes (areas of paint that have consistent color value) or to lighten color-value paint that is too dark by simply spreading it around. You will use this technique every time you paint wet on dry or wet on wet.

When pulling paint to fill an area, I load my brush with the darkest color value that I'll be using for my piece and begin painting at the edge or outline of what I'm painting. Only adding water to my brush, I pull the color toward the center of my subject. So, instead of simply "coloring" something in with a loaded brush and painting each stroke, I'm using the paint that I put down

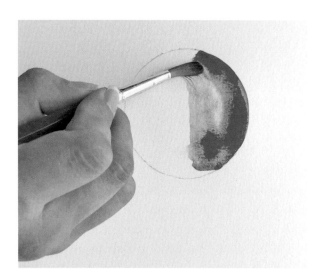

initially and the water on my brush to "pull" the color where I need it to go. This technique creates the look of a gradient wash rather than the solid color of a flat wash.

ERASING WATERCOLORS

If you need to erase a mistake, time is of the essence. As soon as you make your mistake, drop clean water onto the spot or area, take a clean piece of paper towel, and press down on the area to lift the paint. Repeat this until you can't lift the paint any further. If your paint has already been dried, use the same technique, but instead use the tip of your brush to lightly scrub the spot with clean water to activate the paint for lifting.

If your paint hasn't completely lifted, the next step is to dab the area and wait for it to completely dry before taking your sand eraser and lightly erasing the area. The sand eraser will file off the top layers of your paper that have the unwanted paint.

If that doesn't do the trick, the final step is to get your craft knife and lightly scratch the surface of your paper where the spot is. Pay close attention so that you scrape only the fibers that have the paint. Then, alternate between using the craft knife and the sand eraser until your spot is gone. Since we've been working on this area and removing the fibers layer by layer, pay close attention to avoid making a hole in your paper.

WATERCOLOR WASH TECHNIQUES

Watercolor washes are great for making full-page backgrounds and landscapes with skies, oceans, and sunsets, or, in our case, for applying paint to the surfaces on our botanicals. A watercolor wash is an even application of paint over an area where you do not see any defined brushstrokes. Washes can be defined as flat, gradient, or blended and can be done with the wet-on-dry or wet-on-wet technique. When preparing to create watercolor washes, always have two jars of water:

one for holding clean water and one for cleaning your brush. You'll understand why in a second.

FLAT WASH

The flat wash involves painting a solid color without any shading or variation in pigment or color value. You can create a flat wash with the wet-on-dry technique by loading up your brush and painting from left to right as smoothly as possible—without any breaks between your layers and using the same color value for the entire area that you're painting. When painting washes, start by painting one continuous stroke from left to right, before you pick up your brush and start a new one. You'll start your next stroke right where you left off, moving from right to left. This will decrease the amount of times you are picking up your brush, which will help you avoid creating breaks in your wash.

Wet-on-dry flat wash

With the wet-on-wet technique, the initial layer will need to be wet or damp before you begin painting. Here's where that clean water jar comes in. Paint a smooth, thin layer of water on your chosen area; you should be able to see the shine of the water, but the water should not be puddling and sitting on top of your paper. Remember that your initial layer of paint has to be wet when you add your second layer, so time is of the essence here. Make sure you're using a color value that is darker than the value that you want to end up with, since the water that is already on your paper will dilute your paint.

Once you've applied the water, paint your color, moving from left to right and then right to left with each stroke. Take the time to blend the color throughout the rectangle so that it is even. If you're noticing that some areas are more pigmented than others, simply pull your paint and use clean water to blend the extra pigment into your overall piece, or quickly lift the paint up using a clean, dry brush. Painting a wash with the wet-on-wet technique is slightly more forgiving than painting wet-on-dry, as you can very gradually add more clean water to blend the color evenly throughout your rectangle.

Wet-on-wet flat wash

GRADIENT WASH

A gradient wash starts with the brightest hue and darkest color value of a color and fades into lighter color values until the color is barely visible. Or, it can be the opposite, starting with clean water and gradually building more color into the darkest color value.

Wet-on-dry gradient wash

Using the wet-on-dry technique, start by loading your brush with paint at its highest color value. Each stroke should go from left to right and then right to left, starting from the top of your paper to the bottom, while gradually lightening your color value by adding more water to your brush at every brushstroke. You should keep your brushstrokes as smooth as possible, just as you did with the flat wash. As you make your way down the page, load your brush with increasing amounts of water; you should not need to reload your brush with paint.

Wet-on-wet gradient wash

With the wet-on-wet technique, you will repeat what you did with the wet-on-wet flat wash by applying an even layer of clean water. You then begin

applying a second layer, first using the highest color value and lightening your color value by gradually reloading your brush with more water, or a diluted lower-color-value version of the original color. Continue working your way down the area until your gradient wash is completely transparent at the bottom. If you're struggling to apply your second layer of paper before the water in the first layer dries, feel free to evenly wet half of your paper with clean water. After you've painted your second layer of color for this section, work quickly to apply clean water and paint to the remaining half of the paper.

BLENDED WASH

The blended wash is my favorite to work with as you can produce a unique effect. This is also a great way to practice color theory and choosing a color palette. After all, you'll want to select colors that work well together! Before starting, don't be afraid to color swatch to see how colors blend together. In the next examples, I'll use two colors, but know that painting with more than two can be challenging and fun, so try it out!

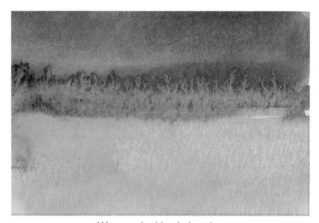

Wet-on-dry blended wash

Choose two colors and activate them with water. To create a blended wash with the wet-on-dry technique, you're simply going to start the same way

you did with the flat wash. On your dry paper, paint your first color evenly halfway down your paper. Halfway through, quickly switch to your second color. Before picking up your second color, make sure to clean your brush so that you don't muddy your second color. Pick up where you left off by painting over the last brushstroke with the second color. You may need to clean your brush again after the initial overlapping brushstroke before reloading it with new paint because your brush will now have picked up two colors. After you've reloaded your brush, continue working your way down to the bottom of your paper.

Painting a blended wash with the wet-on-dry technique is already wonderful, but using the wet-on-wet technique is satisfying—and relaxing. Let's prime your paper with a layer of water, and have your two colors ready to go. Repeat the same strokes that you

Wet-on-wet blended wash

used for wet-on-dry. You'll notice that the colors blend more rapidly since they can travel on the wet paper. I highly recommend that you try this technique with multiple colors.

PROJECT: Abstract Leaf Pattern

Now is your chance to practice a couple of the things you've learned so far! You'll be painting a full page of abstract leaves using different painting techniques. Because you learned a lot about color theory earlier as well, use a color palette of complementary colors. I've chosen a blue, orange, pink, green, yellow, and a light blue for my palette. Feel free to use the same colors, or choose six of your own. Since you also learned about wet-on-dry and wet-on-wet painting techniques. I want you to go ham and paint your leaf shapes in different colors all over your paper, while also overlapping parts of each leaf when they are still wet. Try different color combinations and watch as your colors blend!

What You Need

Watercolor Tool Kit (page 14)
Paper cutter or scissors

1. Cut a sheet of 9 x 12-inch (22.9 x 30.5 cm) watercolor paper down to 8 x 10 inches (20.3 x 25.4 cm). Measure a 1-inch (2.5 cm) border, lightly sketching your lines with a ruler and pencil.

2. With your size 4 round brush, begin painting leaves, using a different color for each leaf. Remember, a leaf consists of two combination strokes, one that forms the top half of a leaf and one that forms the bottom half. The shape of the leaf will look like a marquise gem or a football. Overlap parts of each leaf before the paint dries.

WATERCOLOR BOTANICALS

Day 3: LAYERS & DETAILS

Friends, we are almost there! This section covers the final set of basic skills you'll need to jump into painting botanicals. Using layers, lighting, and shading, especially with the painting techniques you've learned so far, will prepare you to paint anything.

LAYERS

One of the key components of working with watercolor is painting in layers. Painting in layers will help you avoid creating a piece that looks flat and one-dimensional. Generally, there will be three types of layers you'll be painting for all of your illustrations: your base layer, adjustment layer, and detail layer. Often the actual number of layers that you'll paint will be more than three, but this framework will give you an idea of how to organize them all.

Base Layer: Your first layer will always be the base hue of your object. As we've talked about, watercolor is a "light-to-dark" medium, which means that you can only add value, or darken the color, when you add layers, not lighten (unless you are lifting paint; see page 32). Typically, you start with a lighter color value and use it as a foundation upon which to build layers. Remember, it's a one-way, light-to-dark street!

Adjustment Layer: Once your base layer is dry, the next layer can typically be used for shading, if you did not do so already in the first layer with the wet-on-wet technique. You can also use the second layer to adjust color or add abstract details, such as depth and texture.

Detail Layer: The third layer will be the time to add details. This is usually done with the wet-on-dry technique as you'll want clean, fine lines, dots, or defined folds in your finished pieces.

So, what are some techniques we'll use in these layers? Let's dive in.

GLAZING

Glazing is a type of layering that is used mostly with the wet-on-dry technique for full control of shading and color. It is simply painting a layer of paint with the same color to deepen and darken the color, or a different color to provide shading, or depth. You will likely be glazing on top of your base layer or adjustment layer.

Glazing with wet-on-dry technique

Glazing with wet-on-wet technique

HIGHLIGHTS

It is always a good practice to notice where light is hitting the object that you're painting. This will help you decide where you should create highlights. Adding highlights to your painting will also provide a more three-dimensional experience for your viewer.

Here are a couple of ways to create highlights.

Lift Color: You'll often start your painting with a lighter color-value base layer because this lets you create shading by adding darker color value layers of paint. While the first layer of paint is still wet, clean and dry your brush. Using a sweeping motion and light to medium pressure (depending on how big your area is), follow the contour of the top of the circle (a downward C curve) with your dry brush, putting pressure on the brush where you want the highlight to be. In this example, the light is hitting the top half of the sphere. This will lift the color up in a subtle way. Working wet on wet allows you to avoid the hard-edged lines that result when you paint wet on dry.

Leave negative space: Another way to create a highlight is using pencil to sketch the shape of the highlight, or simply paint around the space where the highlight will be. As I've mentioned, we want to avoid using pencil whenever possible, since you can't erase pencil after painting over it; as you become more comfortable with painting, try eyeballing where you should have negative space. Note that once the layer with the negative space dries, you will see hard lines around the highlight because you have not painted a gradient wash into the white paper. If that's not the effect you want, you can

take a clean wet brush to blend the hard edges while you're painting wet on wet or after your layer has dried.

Use white paint: If you use white paint to create highlights, you should add the highlights when you paint the final details layer or the layer right before this one. The key to using white paint is to load the paint at its thickest and most opaque and dilute it gradually so as to not lose the opacity of the paint. I recommend using the wet-on-wet technique if you want to use white to paint in the highlight while the previous layer is still wet. This will allow the highlight to blend into the previous layer and look less harsh.

SHADING

Everything that you've learned in this section so far leads us to shading. Shading is essentially painting the shadow on a subject. Because darkness contrasts the effect of light, shading helps accentuate the visual aspect of a highlight. Here are a couple of ways to create shading using a strawberry as our subject.

Pulling paint: My preferred way of creating a base layer with shading is to start with a dark color value, apply that value to the area where the shading will go, add water to my brush, and pull the paint upward into the lighter areas of the object. (Here, it would be the bottom of the strawberry if we're imagining the light to come from above.)

Glazing: Use the lowest-color-value paint for the base layer, wait for the first layer to dry and then glaze using your shading color, starting at the bottom of the strawberry and blending it upward about halfway up the strawberry, just as you do when creating a wet-on-dry color blending wash.

Use shades and grays: Remember that color wheel? If you need to create a color to paint shadows or an area on the object that does not face your light source, you can mix a hue with black to create a shade or with its complementary color to create a gray that has hints of the original hue.

DETAILS

The final layer in your piece will always be the details layer. You'll decide whether you want to use the wet-on-dry or wet-on-wet technique, depending on the details that you're trying to produce. For most of the projects in this book, we'll be using the wet-on-dry technique because we want clear, crisp details to represent the folds, bends, and veins on your watercolor botanicals. Often, you'll use the same color paint as your previous layers but in a darker color value to help the details stand out, but sometimes you'll use a color that is similar to another one used in a previous layer

(for example, using red orange to add details on top of orange layers). I also like to use white paint to make details pop.

Contouring

Contouring can make our botanicals look more lifelike and natural. **Contour lines** represent the edges or outlines of your painted object; the edges of what you've painted will form your contour lines. **Cross-contour lines** or **contour surface lines** flow over the object you're painting and help communicate the form and volume of an object to your viewer.

In this example above , notice how the lines follow the globe's round outline and also pull the globe into a spherical shape toward your eyes. Because, you know the world isn't flat, right?

In the case of the cactus below, its cylindrical shape becomes defined as you add the vertical and horizontal lines.

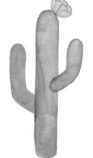 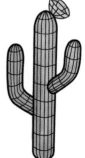

Cross-contour lines follow the general outline of an object and show the curves, dips, and folds that make up the form of the object. When you follow cross-contour lines as a reference for painting details, you can give a flat painting a three-dimensional, realistic look. You'll use cross-contour lines to put the finishing touches on your botanicals, like the curves of a flower petal or leaf. Throughout this book, I'll refer to them as **contour detail lines**. They will be included in the line drawings I've provided in each tutorial for reference.

Remember the brushstrokes and shapes that we learned about in Painting Techniques (page 30)? You'll find that we use a combination of C and S curves to render final details that follow the cross-contour lines of an object. Let's run through some examples to get your eyes trained and ready to go!

Here is an example of the cross-contour lines on two simple buttercup flowers (shown on the next page), one facing front and one from the side. From our perspective, the center of the front-facing flower is deeper and farther away from us than the edges of the petals. Notice that the vertical cross-contour lines follow the outline of the petals and meet in the center of the flower. The center of the flower is spherical and comes toward us. The petals fold inward, away from

us, which means we're seeing the edges on the outside of the petals.

For the flower on its side, the side with the exterior of the petals is closest to us, and we have a partial view of the inside of the petals that are farthest from us. The petals that are closest to us in view fold outward, giving us a tiny peek of the inside edge of those petals. The horizontal cross-contour lines accentuate the cuplike shape of the flower.

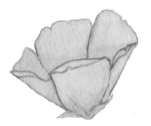

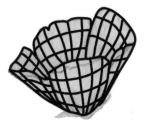

How do you use these cross-contour lines in your paintings? When you're ready to add the layers with final details, you will follow the cross-contour lines and start from both the inner and outer edges of each petal (inner indicating the area around the center of the flower, and outer indicating the area along the rim of the flower). You will typically add loose C and S curves, as well as elongated triangle-shaped shadows, to show the viewer which features of the plant are curling inward, outward, caving in, and so on.

When you want to paint a petal that is curling inward, you will paint a line following the edge shape of the petal just inside the edge with a darker color value, and then fill that space with the darker value paint to show that the other side of the petal is curling forward and visible to the viewer. Notice that I added

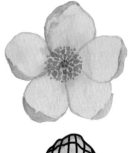

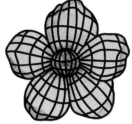

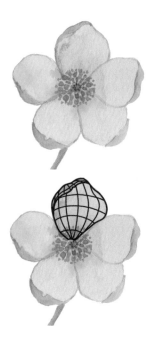

a little "V cut" to make the petals' edges rougher and more natural looking. For botanicals, you'll typically follow the vertical cross-contour lines to paint contour detail lines that will accentuate the direction of the curl on the outside of the petal and on the inside. Painting the inward curls and painting the cross-contour lines will complete your flower.

When you want to paint a petal that is curling outward, use a darker color value and bring your

brush to the top edge of the petal and move it down and into the petal slightly. Moving from left to right, paint an upward C curve line to create the outward curl. I also added an upside-down V cut into the petal. Then, following the vertical cross-contour lines, paint in your contour details lines to finish your flower. Here's what your final piece will look like with the watercolor contour detail lines! Here's what your final piece will look like with the watercolor contour detail lines!

PROJECT: Orange with Highlighting & Shading

Now, let's put these techniques to work. We'll paint an orange to practice highlighting and shading. In this project, the light will be coming from the top left corner and down onto the top left of your orange. You'll paint this orange using mostly curved strokes that follow the round shape of orange.

What You Need

Watercolor Tool Kit (page 14)

Techniques

Lifting paint (page 32)
Wet on wet (page 32)
C curve (page 30)
Pulling paint (page 34)
Wet on dry (page 32)

Colors

Cadmium yellow hue (1)
Cadmium red pale hue (2)
Gray (ultramarine +
 cadmium red pale hue) (3)
Burnt umber (4)
Viridian hue (5)

1	2	3	4	5

1. With cadmium yellow and your size 4 brush, paint a circle, leaving a small star-shaped space unpainted for the stem. This will be the first layer of the orange. While the yellow layer is still wet, follow the curve of the orange with a dry brush, using a sweeping motion to lift up the yellow on the top left to create a highlight **(A)**. You may need to dry your brush and repeat this sweeping motion a couple times until the highlight is almost white.

2. While the yellow layer is still wet, pick up cadmium red pale hue paint with your brush and outline the circle using the tip of your brush. You should see the cadmium red pale hue bleeding into the yellow, as we're using the wet-on-wet technique here. When you get to the bottom right section of the outline, continue following the outline using an upward C curve shape. Blend the cadmium red pale hue up into the yellow circle about one-third of the way around the circle, pulling the cadmium red pale hue upward and gradually blending it into the yellow **(B)**. Use water as needed to blend the orange into the yellow; move your brush in a sweeping motion until the blend is smooth. Let this layer dry.

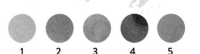

Tip: If you accidentally paint over the highlight, lift up the paint with a dry brush.

3. Mix a small amount of ultramarine with the cadmium red pale hue to create the gray that you'll use to paint a shadow on the bottom right of your circle. Outline the bottom right of the circle with the gray. Using an upward C curve motion, pull the gray color up into the circle **(C)**. You should fill about one-quarter of the circle.

4. You'll use the wet-on-wet technique to paint the bumps on the orange's surface. Mix cadmium red pale hue and burnt umber together to produce a slightly muddier orange. Using your size 0 brush, start loosely painting dots by simply touching the tip of your brush to the paper in the shaded area, following the curve of the circle. Since this area should still be wet, the dots will diffuse slightly into the previous layer.

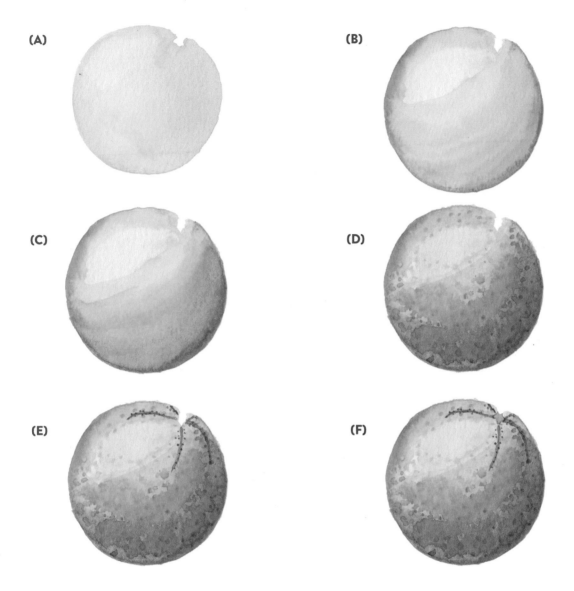

(A)

(B)

(C)

(D)

(E)

(F)

Clean your brush and add a thin layer of clean water onto the rest of your orange, starting at where the shaded area ends and moving upward. With your cadmium red pale hue, continue making more dots, starting from where you left off earlier. The dots should follow the shape of an upward C curve; stop when you reach the highlight, about one-third of the way up from the shaded area.

Add the last layer of dots around the highlight and the top of the orange, using yellow cadmium hue **(D)**.

Your dots will blend into the water added in the earlier step. They will be visible but not extremely defined. Let this layer dry.

5. Using burnt umber and the very tip of your brush, paint curved contour detail lines around the space for the stem to emphasize the dips in the orange's rind. Add small dots around the fine lines to add depth **(E)**.

6. With viridian hue, paint a five-pointed star in the negative space to create the stem **(F)**. The points of the star should connect to the brown lines added in step 5.

rhomboid

lanceolate

cordate

obtuse

orbicular

palmate

deltoid

lyrate

ovate

LEAF SHAPES

Leaves

The perfect place to start on this botanical journey is with the leaf. Leaves are such an important part of a plant as they are responsible for turning sunlight into energy and food for the entire plant. Just like us humans, they come in different shapes, sizes, and personalities. Sometimes, they function as the main feature of a plant; other times, they are a sassy supporting actor to a flower. We'll learn how to paint several types of leaves in this chapter—all of which have unique looks, require different techniques, and are perfect as decorative foliage or the main subject of your painting.

LEAF ANATOMY

Before we dive in, let's touch on the basic anatomy of a leaf and how we'll approach painting one. Though leaves can have many different shapes and characteristics, they all generally have the same structure. All leaves have a **midrib**, which is the "spine" of the leaf and connects the leaf to the plant's stem. I generally like to paint the midrib first using loose C curves or, in some rare cases, straight lines.

The **base**, or bottom of the leaf, is attached to the **petiole**, which is the stalk that attaches the leaf to the plant stem. The **veins** are the vascular tissues that deliver water and food throughout the leaf. They can

look like thin lines and have arrangements that all start from the midrib and extend throughout the leaf. We'll use loose C and S curves and some occasional straight lines to paint leaf veins.

I'll refer to the **apex** of the leaf as the end or tip of the leaf and the **margin** as the features of the edges of the leaf. You can also refer to a full page of leaf shapes on the previous page.

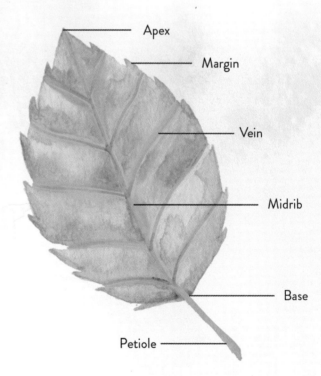

Apex

Margin

Vein

Midrib

Base

Petiole

Day 4: LEMON LEAF

When life gives you lemons, paint them—and their leaves! Lemon trees are native to South Asia, and its fruit and leaves are popular for both culinary and nonculinary uses. For painting, the lemon leaf has a common leaf shape that I like to use in both abstract and more realistic paintings. In floral arrangements, you might have heard of filler leaves called lemon leaves, but they often come from salal shrubs instead of lemon trees. Don't get them mixed up! This bright green, yellow-hued, oval-shaped lemon leaf with a slightly rough margin does indeed grow on actual lemon trees.

What You Need

Watercolor Tool Kit (page 14)

Techniques

S curve (page 31)
Boomerang stroke (page 31)
Wet on wet (page 32)
Wet on dry (page 32)
C curve (page 30)

Colors

Viridian hue (1)
Sap green (2)
Dark green (ivory black +
 viridian hue) (3)

1 2 3

1. Start by creating a midrib to use as a center guideline. Using viridian hue and a size 4 round brush, paint a very loose backward S curve **(A)**.

2. Use sap green to paint the left half of your leaf. Place the tip of your brush just above the bottom of your midrib and start the base of your leaf with a boomerang stroke, tapering off the boomerang shape and ending your stroke at the end of your midrib to create one side of the leaf's apex. Continue by adding one or two additional strokes to paint all the way to the midrib. Wiggle your brush as you move outward and upward the leaf to make the edge of the leaf look slightly wavy **(B)**.

3. With the paint on this side of the leaf still wet, pick up viridian hue with your brush and line the edges and bottom half of the leaf **(C)**. The viridian hue will blend with the sap green.

4. Repeat steps 2 and 3 to paint the right side of your leaf by moving your brush in the opposite direction and matching the left side of your leaf **(D)**. Wait for the layers to dry.

5. For the vein details, pick up viridian green with your size 0 round brush. Repaint the midrib to darken and thicken it. Starting from the base of your leaf, paint veins that branch out diagonally upward from the midrib to the outer edges of your leaf. Repeat this step to create more veins along the midrib until you reach the apex of the leaf **(E)**.

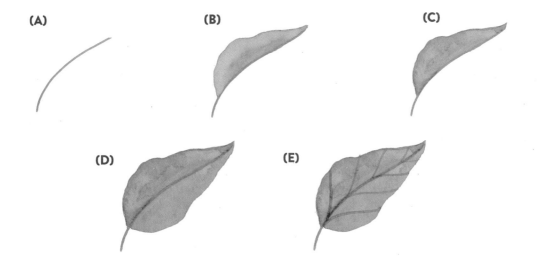

(A) (B) (C)

(D) (E)

BOTANICAL BONUS: Lemon Leaf Side View

Rarely will all of our leaves lie completely flat and face the front when we're painting, so here is an extra challenge to paint a side view of the lemon leaf. The underside of the leaf's right side will be closest to us in view, while the top of the left side is farthest from our view.

1. Follow steps 1–3 from the lemon leaf tutorial on page 48 to paint the midrib **(A)** and first side of the leaf on the top of the midrib **(B)**. This side will now be the bottom of your right leaf. Let this layer dry.

2. To paint the left side of the leaf peeking out from behind the right side, start right under the base of the right side of the leaf and paint a C curve that reaches up and tapers off about halfway up the leaf **(C)**. Let your paint layers dry.

3. Paint your veins with your size 0 brush and dark green paint **(D)**.

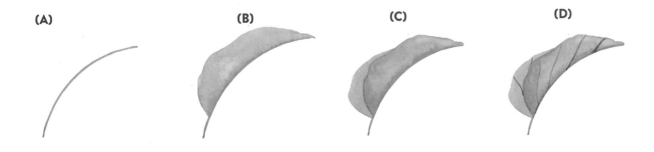

(A) (B) (C) (D)

PROJECT: Lemon and Lemon Leaves

Let's paint the lemon leaf in a more realistic setting: attached to its lovely friend, the lemon. Lucky for us, we learned how to paint an orange in the last chapter (page 44), so this project will be fairly similar but with the addition of two beautiful lemon leaves. We'll be creating a lemon hanging from a stem with two leaves, with light hitting the lemon from the top left.

What You Need

Watercolor Tool Kit (page 14)

Techniques

Wet on wet (page 32)
Lifting paint (page 32)
C curve (page 30)
Pulling paint (page 34)
Wet on dry (page 32)

Colors

Cadmium yellow hue (1)
Gray (cadmium yellow + dioxazine purple) (2)
Viridian hue (3)
Sap green (4)

1 2 3 4

1. Using the size 4 brush, start with a light color value of cadmium yellow and paint the first layer of the lemon. While the yellow base is still wet, follow the curve of the top of the lemon with a dry brush, using a sweeping motion to lift up the yellow and create a highlight **(A)**. You may need to dry your brush and repeat this sweeping motion a couple times until your highlight is almost white.

2. Mix a little bit of purple with cadmium yellow to create the gray that you will use to paint a shadow that sits on the bottom right of your lemon. Using the same sweeping motion from step 1, but this time with an upward C curve, paint the bottom of the lemon and pull the gray upward so that the paint fills about one-third of the lemon. Use clean water to blend the gray into the yellow **(B)**. Wait for this layer to dry.

3. Using your size 0 brush and cadmium yellow paint, add dots along the bottom of the lemon. Stop when you reach one-quarter of the way up from the bottom. Add dots around the highlight to accentuate it **(C)**.

4. With your size 0 brush and cadmium yellow, paint contour lines on the top end of the lemon to depict the dips in the part of the rind that leads to the stem. Repeat for the other end of the lemon. Add some additional dots around these detail lines **(D)**.

5. With your size 0 brush and viridian hue, paint the stem. Starting at the top right of the lemon, paint a loose backward C curve. Thicken the ends of the C curve **(E)**.

6. Time for the lemon leaves! Using the tutorial on page 48, add a leaf to the left of the lemon stem by painting its midrib using a loose backward C curve **(F)**. The apex of the leaf should point to the top left of your paper.

(A)

(B)

(C)

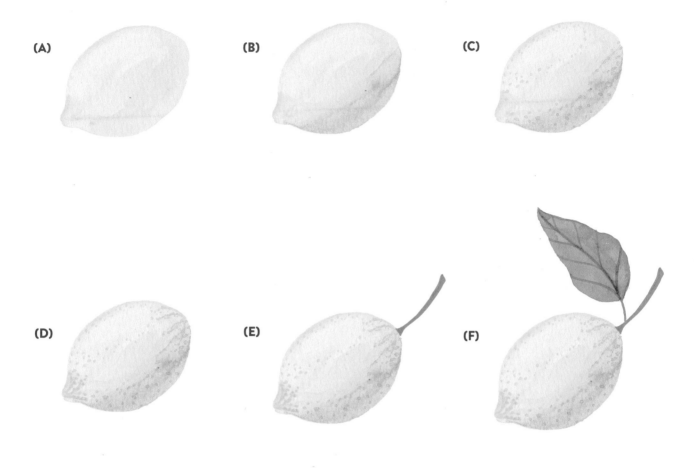

(D)

(E)

(F)

7. To the right of the lemon, you'll create a side view of a second leaf. Repeat the steps outlined in the Botanical Bonus on page 49, but this time, use a loose C curve midrib that points to the bottom right **(G)**.

(G)

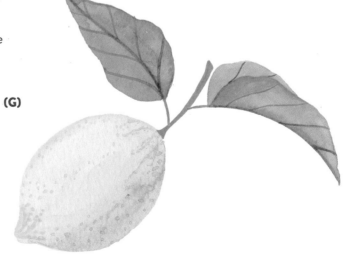

Day 5: OLIVE LEAF

The olive leaf is one of my favorite leaves to paint because the colors of their tops and bottoms contrast beautifully. The top side of the olive leaf is a waxy dark green, while the underside is a silvery matte green. I love that the two colors in one leaf create a dimensional look, whether you're painting a single olive branch, a wreath, or foliage for a flower arrangement. Olive leaves are lanceolate, meaning that they're long and thin. They have a smooth margin and pointed apex. You'll first paint the top and bottom sides of the olive leaf, and then an olive branch.

What You Need

Watercolor Tool Kit (page 14)

Techniques

C curve (page 30)
Combination stroke (page 31)
Wet on dry (page 32)

Colors

Dark green (ivory black + viridian hue) (1)
Gray green (Chinese white + ivory black + viridian hue) (2)

1 2

1. Let's start with an olive leaf with its top side showing. With your size 4 brush and dark green paint, use just the tip to paint a loose backward C curve to create a midrib that points to the top right of the paper **(A)**.

2. The strokes that you'll need to create the rest of the olive leaf are simple. With your dark green paint, use a thin combination stroke to create the top half of the leaf **(B)**. Place it close to the midrib to elongate the leaf. Repeat this step to create the bottom half of the leaf **(C)**. Wait for the leaf to dry.

3. Once your leaf is dry, repaint the midrib with your size 0 brush and dark green.

4. For a leaf with its underside showing, mix black and white together to create a gray and then add viridian hue to create a gray green that is softer than the dark green used for the top side of the leave. With the size 4 brush and dark green, repeat step 1 to paint your midrib **(D)**.

5. With your gray green, repeat step 2 to create the top and bottom halves of the leaf **(E, F)**. Wait for the leaf to dry.

6. Once your leaf is dry, repaint the midrib with your size 0 brush and dark green .

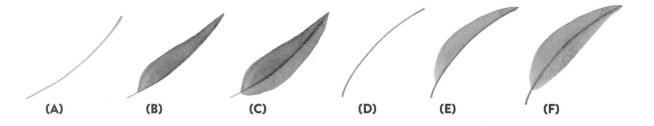

(A) (B) (C) (D) (E) (F)

PROJECT: Olive Branch

The olive branch symbolized peace or victory in ancient Greek culture. This gorgeous branch features simple purple-and-black-hued olives and leaves whose tops and bottoms alternate.

What You Need

Watercolor Tool Kit (page 14)

Techniques

C curve (page 30)
Lifting paint (page 32)
Wet on wet (page 32)
Wet on dry (page 32)

Colors

Burnt umber (1)
Purple black (dioxazine purple + ivory black) (2)
Dark green (ivory black + viridian hue) (3)
Gray green (Chinese white + viridian hue) (4)

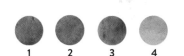

1 2 3 4

1. With your burnt umber and size 4 brush, paint a long, loose C curve, moving from the bottom left of your paper to the top right **(A)**. This will be the stem of your olive branch; the top end points to the right.

2. With your size 4 brush and purple black, paint an oval shape beneath the bottom end of the branch. Make sure to leave space between the branch and the olive, as we'll paint stems to connect the olives to the branch later. Dry your brush. While the olive's paint is still wet, follow the top of the olive with the brush, moving it in a downward C curve stroke. Press and lift up some of the paint to create the highlight **(B)**.

3. Repeat step 2 to add three more olives, one above the branch and two more beneath the branch at the top end **(C)**.

4. Using your size 0 brush and burnt umber, connect the olives to the branch by painting thin stems **(D)**.

5. Start painting the olive leaves at the base of your branch with your size 4 brush. Using dark green, paint the top-facing olive leaves, alternating their placement above the branch and below it. Connect your midrib and leaves directly to the brown branch **(E)**. Don't forget to leave room for the bottom-facing leaves.

6. Repeat step 5 using gray green to paint the bottom-facing leaves and complete the branch **(F)**. You can also let an olive overlap a leaf. To do this, leave a very thin negative space between the leaf and the olive to avoid blending, or just make sure your olives are dry before painting the leaves.

(A) **(B)**

(C) **(D)** **(E)** 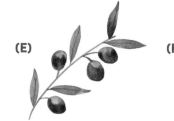 **(F)**

Day 6: SILVER DOLLAR EUCALYPTUS LEAF

The silver dollar eucalyptus is the perfect romantic greenery to accompany pastel florals and can even shine on its own. These leaves have a chalky finish and come in many different tints and shades, including muted blue and dark green. The leaves also come in varied shapes—round, heart—shaped, and oval. For this leaf, I like to use the wet-on-wet technique to create depth and mix several different shades to re-create the leaves' unique finish. You need to keep the layers wet as you're painting, so have your paints ready before starting and remember to move quickly. We'll walk through how to paint three different leaf shapes.

What You Need

Watercolor Tool Kit (page 14)

Techniques

Wet on wet (page 32)
Pulling paint (page 34)
C curve (page 30)
Wet on dry (page 32)

Colors

Dark green (ivory black + viridian hue) (1)

Dark blue green (ultramarine + dark green) (2)

1. Using your size 4 brush, paint a loose peach-shaped leaf with clean water. The leaf should look like a wide heart, with the bottom coming to a point; this is where the petiole will connect to the leaf. Load your brush with dark green and outline the layer of water, starting from the top left and continuing all the way around the leaf. Then pull the color inward into the rest of the leaf with your brush **(A)**. You should see the dark green diffuse beautifully into the clean water.

2. Quickly clean your brush and load it with the dark blue green. Start lining the edges of your leaf with dark blue green **(B)**. Because your layers are still wet, you can play around with pulling and dropping in more color. Each leaf will have a unique look once it dries.

3. Once the leaf is dry, use your size 0 brush to paint a slight C curve and create a midrib, moving from the bottom point of your leaf to the top **(C)**.

4. Repeat steps 1–3 to paint the next two leaves, but omit the dip at the top of the leaf and create a wide, rounded, teardrop-shaped leaf instead **(D)**. For the third leaf, do the same and elongate its shape into an oval **(E)**.

Tip: Paint a couple of leaves to help you practice the wet-on-wet painting and pulling color into the clean water. If your layers dry before you're able to paint, simply add a layer of clean water and start again.

1 2

(A)

(B)

(C)

(D)

(E)

PROJECT: Silver Dollar Eucalyptus Stem

The eucalyptus tree symbolizes purification and the division between the heavens and Earth. Pretty epic, right? Here, we'll practice what we just learned and paint a eucalyptus stem with leaves that occasionally overlap for a realistic yet whimsical look.

What You Need

Watercolor Tool Kit (page 14)

Techniques

S curve (page 31)
Wet on wet (page 32)
Pulling paint (page 34)
C curve (page 30)
Wet on dry (page 32)

Colors

Burnt umber (1)
Dark green (ivory black + viridian hue) (2)
Dark blue green (ultramarine + ivory black + viridian hue (3)

1 2 3

1. Using your size 0 brush and burnt umber paint, make a loose S curve to create the stem **(A)**.

2. It's leaf time! Use the tutorial on page 54 to paint each leaf, and have fun using all three shapes **(B)**. Alternate the placement of your leaves between the left and right sides of the branch. You can arrange the rounded sides of your leaves in different directions to make the branch look more natural. Just remember that we are going to connect the leaves to the stem with petioles, so leave space between the leaves and the stem, and orient the pointy base of each leaf toward the stem. If you like, you can overlap some leaves; when doing so, decide which part of the overlapping leaves are visible. Paint leaves that are partially covered by leaving a thin negative space between the overlapping leaf and the partially covered leaf to avoid blending. You can also wait until the overlapping leaf has dried. When finished, let all your leaves dry.

3. Using your size 0 brush and dark green, paint midribs on your leaves **(C)**.

4. Clean your size 0 brush and grab burnt umber to paint thin, wiggly petioles connecting each leaf to the branch **(D)**. If needed, darken the stem to finish your piece by using your size 0 brush and burnt umber to carefully apply another layer of paint.

(A) **(B)** **(C)** **(D)**

 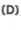

Day 7: GINKGO BILOBA LEAF

With its fanlike shape and delicate veins, the gingko leaf is one of the most beautiful leaves. Ginkgo biloba trees have been around nearly forever. There's a theory that says the species is prehistoric-dinosaur-level old; some even consider it a living fossil. Typically green throughout the year, the leaves turn a golden yellow in the fall, which will make the pieces that we're painting even more fun. (Did your blending radar go off? Because mine did!) Before you get started, you'll need to envision the fanlike shape of the gingko leaf. You can use my outline for reference here or go straight to painting.

What You Need

Watercolor Tool Kit (page 14)

Techniques

C curve (page 30)
Wet on wet (page 32)
Wet on dry (page 32)

Colors

Viridian hue (1)
Cadmium yellow hue (2)
Opaque white (3)

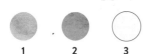

1 2 3

1. Using your size 0 brush and viridian hue, paint a loose backward C curve to create the stem and petiole **(A)**.

2. We're going to start with the left side of your leaf. Using your size 4 brush and viridian hue paint, create a small triangle halfway up the stem, using the curve as one side of the triangle **(B)**.

3. While the paint is still wet, begin blending upward and outward from the curve to create the fan shape that you see in my outline drawing above. After you've filled the shape about halfway, clean your brush and transition to using cadmium yellow hue. You should see the colors immediately blend. Complete the fan shape and make sure to paint a jagged, slightly curved edge along the top of your leaf. When you reach the C curve you painted in step 1, pull down your brush to meet the end of the curve **(C)**.

4. Repeat step 3 in the opposite direction to paint the right side of the leaf **(D)**. Let both sides dry.

5. Here comes the fun part! Use your size 0 brush and opaque white to paint over the first C curve you made, starting at the base of the leaf up to where the leaf comes to a V. Then paint the tiny, delicate veins of the leaf, starting from the center and moving to the edges of the leaf by following its contour lines **(E)**. The key to the fanlike shape is to start each detail line from the same place, ideally where the base of the leaf meets the start of the petiole.

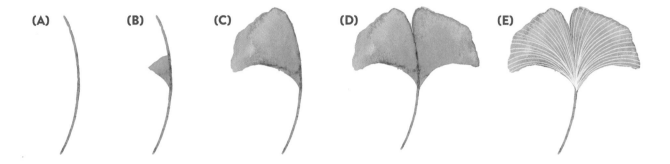

(A) (B) (C) (D) (E)

PROJECT: Trio of Ginkgo Leaves

For this project, we'll paint a cluster of three gingko leaves centered vertically on your piece of watercolor paper.

What You Need

Watercolor Tool Kit (page 14)

Techniques

C curve (page 30)
Wet on wet (page 32)
Wet on dry (page 32)

Colors

Viridian hue (1)
Cadmium yellow hue (2)
Opaque white (3)

1. Measure your paper and cut it into an 8 x 10-inch (20.3 x 25.4 cm) sheet. With a ruler and pencil, measure and mark 1 inch (2.5 cm) from each edge of the paper. If you like, sketch a light line down the center of your paper, 4 inches (10.2 cm) from each vertical side.

2. Using your size 0 brush and viridian hue, start by painting a loose backward C curve in the center of your paper (A). Position the curve along the center line of the paper. This will form the stem off which each leaf will branch. This stroke will also become the petiole for the middle leaf.

3. Paint a backward C curve, starting about one-third up the stem and pointing to the left. This will form the left gingko leaf. Then paint another C curve starting just above the last one and pointing to the right of the stem (B).

4. Paint your three ginkgo leaves using the steps outlined on page 56 (C). Feel free to vary the sizes and shapes of each one.

1 2 3

(A)

(B)

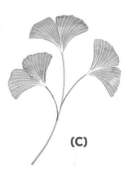

(C)

Day 8: FERN

Many of us may know the fern as one of the plants our grandma hosted at home, likely in some sort of seashell or hanging macramé pot. It also happens to be quite an old plant. Some species have shown up in fossils dating as far back as 360 million years ago. (The gingko has some competition!) I personally love painting fern fronds, which look like a branch from the plant, because of its delicate pinnules, the mini "leaves" on each pinna, or arm of the fern frond. We'll start by painting a pinna.

What You Need

Watercolor Tool Kit (page 14)

Techniques

C curve (page 30)
Wet on wet (page 32)

Colors

Dark green (viridian hue +
 ivory black) (1)
Hooker's green dark (2)
Sap green (3)

 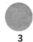

1 2 3

1. Using your size 0 brush and dark green, paint a loose C curve to create what will be the "midrib" of the pinna **(A)**. (Remember, this is just one pinna, or arm, of the fern, so the fern frond will have the actual midrib.)

2. To paint the leaflets, or pinnules, load your size 4 brush with dark green paint. Starting at the bottom of the midrib, simply touch the tip of your brush to the midrib. The tip should be perpendicular to the midrib. Press the brush onto your paper and lift **(B)**. This technique is called stamping, and you should see a variation in color value in your pinnules with some areas darker and some lighter depending on the pressure you're applying to your brush.

3. Stamp a matching pinnule on the other side of the midrib **(C)**. Feel free to turn your paper to make it easier.

4. The base of the pinna will always have longer pinnules, so once you are about one-third of the way up the arm, gradually decrease the length of your brush stamps by applying less pressure and letting less of the brush touch the paper. From here, we're also going to start transitioning colors on the pinna, as the pinnules typically get lighter toward the tip. One-third of the way up the pinna, clean your brush and begin stamping shorter pinnules with Hooker's green dark. Add pinnules to the last third of the arm using sap green paint; leave about ¼ inch (6 mm) of space for the end pinnules **(D)**.

5. With your size 0 brush and sap green, finish the pinna by painting tiny teardrop-shaped pinnules along the left and right of the apex, ending with one at the top of the midrib **(E)**. If you need more room to finish bringing your pinna to an end, extend the midrib by painting a thin line at the end of your midrib.

(A)

(B)

(C)

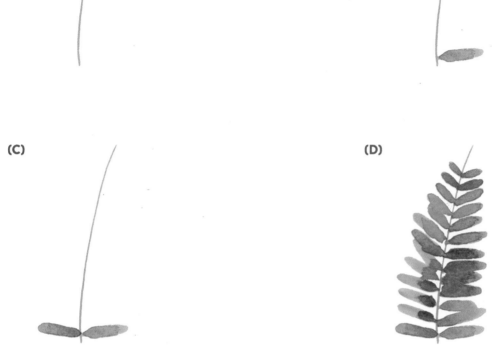

(D)

(E)

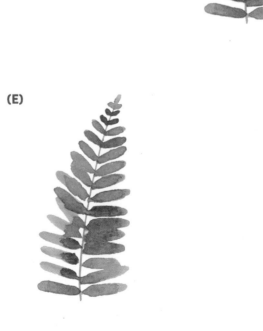

PROJECT: Fern Frond

You've learned how to paint one piece of the fern, so let's put it all together to paint a full fern frond. You, my friend, already have all the paints from the pinna tutorial, so you're ready to jump right in! The fern frond is generally shaped like a tall isosceles triangle, meaning the pinna will be longer on the bottom of the frond and gradually become shorter and shorter as you move up the midrib. Feel free to position your fern frond in the center of your watercolor paper—just make sure to measure a border around the edge of the paper and mark the center of your paper before starting.

What You Need

Watercolor Tool Kit (page 14)

Techniques

C curve (page 30)
Wet on wet (page 32)

Colors

Dark green (viridian hue + ivory black) (1)
Hooker's green dark (2)
Sap green (3)

1. With your size 0 brush and dark green, paint the midrib of the frond on the center of your paper using a C curve **(A)**. The stroke should curve very slightly and look almost straight.

2. Continue using your size 0 brush and dark green to paint the first pinna at the bottom right of the midrib. Create the pinna's midrib with a loose C curve **(B)**. Start painting your pinnules following the tutorial on page 58 **(C)**.

4. Repeat steps 2 and 3 to create a matching pinna on the other side of the midrib **(D)**.

5. Repeat steps 2–4 to continue painting matching pairs of pinna along the midrib. As you move up the midrib of the frond, make sure to shorten the pinna gradually **(E)**. Feel free to point the tips of the pinnae upward and downward for a more relaxed look.

6. To finish the frond, paint a single pinna at the very end of the midrib **(F)**. Feel free to extend the midrib as needed.

(A) **(B)**

(C)

(D)

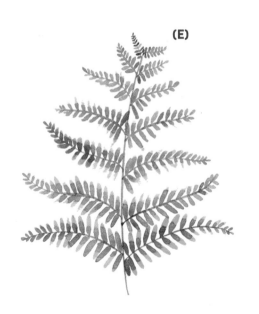

(E)

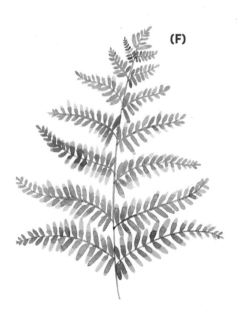

(F)

Day 9: LEAF PATTERN

Great job! You're almost done with the leaf section of this watercolor journey! To finish, let's get creative and put all five leaves that you've painted in one piece. For this combination project, we're painting an allover leaf pattern with some leaves extending past the edge of your paper. When creating a pattern, don't worry about exact spacing. You want to focus on an organic flow of illustration and make sure the illustrations are spread evenly throughout your piece. You're also going to use what you learned about composition with the rule of thirds (page 18). When the paper is divided into thirds, you can break down your piece into nine different sections; each section contains three leaves. Even if some of the leaves are barely peeking into the section, the entire piece feels evenly spaced.

What You Need

Watercolor Tool Kit (page 14)

Techniques

S curve (page 31)
Combination stroke (page 31)
Wet on dry (page 32)
Wet on wet (page 32)
Pulling paint (page 34)
Boomerang stroke (page 31)

Colors

Dark green (ivory black + viridian hue) (1)
Gray green (Chinese white + viridian hue) (2)
Hooker's green dark (3)
Sap green (4)
Dark blue green (ultramarine + dark green) (5)
Viridian hue (6)
Cadmium yellow hue (7)
Opaque white (8)

1. You will paint your leaf pattern on a sheet of 9 x 12-inch (22.9 x 30.5 cm) watercolor paper. To start, let's sketch the lines for the rule of thirds. Using your pencil, divide your paper into nine boxes by very lightly drawing two horizontal lines, one 3 inches (7.6 cm) from the bottom edge of the sheet and the other 6 inches (15.2 cm) from the bottom edge, and two vertical lines, one 4 inches (10.1 cm) from the left edge and 8 inches (20.3 cm) from the edge. Your pencil lines should be so light that you can barely see them.

2. You're going to paint sprigs of leaves one line at a time. Starting in the top left corner and box, paint a sprig of olive leaves (page 52) that point toward the bottom right corner of the paper **(A)**. I always like to point the corner illustrations toward the center of the paper to direct the focus to the center four focal points. Make sure to paint the sprig to look as if part of it has been cut off from our view. You can do this by painting only part of a leaf at the base of your midrib.

3. You will paint a fern leaf (page 58) and a silver dollar eucalyptus (page 54) next **(B)**. Each plant should overlap the grid lines of the next two boxes. Point the fern slightly to the top right, and flip the eucalyptus sprig so that it points to the bottom left.

(A)

(B)

(C)

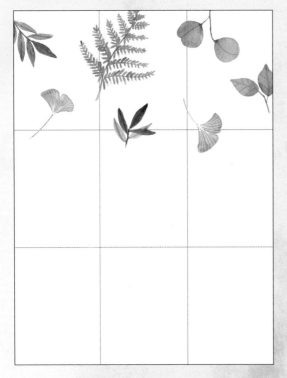

(D)

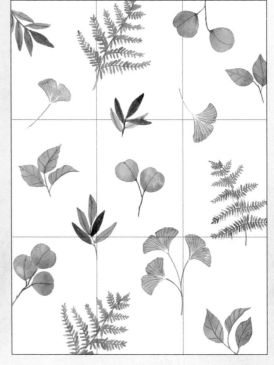

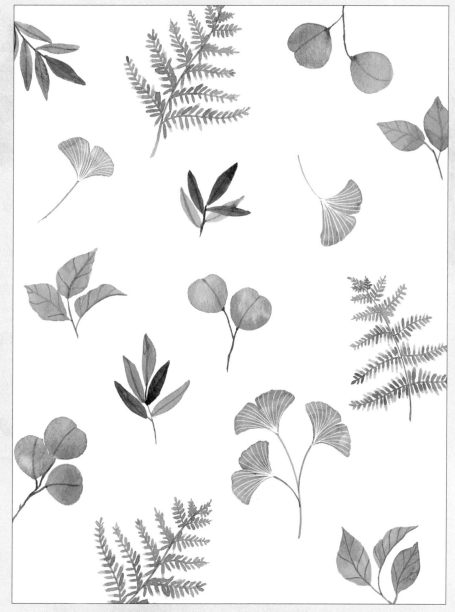

4. To create the next row of leaves, look for spaces between the leaves in the previous row and remember to make sure that you have three illustrations per box. One illustration can do double duty and serve as one illustration for two boxes. After you've decided on the placement of your illustrations, add them to your piece. Here, I painted two separate gingko leaves (page 56), a sprig of olive leaves, and a sprig of lemon leaves (page 48) **(C)**.

5. Repeat step 4 until you fill the entire paper with leaf illustrations, alternating them so that the same leaves aren't next to each other **(D)**. Take your time as this is a great way to practice composition and spacing.

6. After all of your leaves are dry, erase your pencil lines, and you're done **(E)**! New wallpaper anyone?

Flowers are nature's
way of telling us
that we must
embrace our own
beauty & grow
with intention.

Flowers

Flowers are one of Mother Earth's greatest gifts to us humans. They are nature's eye candy, used to celebrate, honor, and bring joy to our lives! Often seen as representations of sentiment in life, flowers come in all shapes, sizes, colors, and meanings. I hope you're as excited as I am to dive into the flower series that I've prepared for you!

FLOWER ANATOMY

Let's start this chapter with the general anatomy of a flower. I know you probably have basics like the petals and the stem down, but this in-depth look will help us as we prepare to paint other sections of the flower.

Most flowers have a round structure at the top of a stem and are made up of five general parts. At the very center of your flower is the **pistil.** This is where all the reproduction of the plant happens and serves as the point where all the other parts of the flower connect. The pistil is made up of the **stigma**, which is typically at the center or top of the pistil and is the most visible part of the flower when it blooms. The stigma is held up by the **style**; this is a long slender stalk that you see on the hibiscus painting right. The style connects to the flower's ovary, which for us isn't typically visible and won't be painted.

Next, we have the **stamens**, which are made up of filaments and anthers. On this hibiscus, the filaments are the thin stemlike structures that attach to the style, and the anthers sit at the end of the filament and hold pollen.

A flower's **petals** (or the corolla) are the colored structures that give a flower its personality and character. Beautiful to us, the petals also attract insects or animals that pollinate the flower.

The **sepals** look like small leaves and hug the base of the flower. They encase the body of the flower, protect the flower as it develops, and are the perfect green detail to add. Lastly, we have our **stem**, which connects the entirety of the flower to the rest of the plant.

Now that you know more about flower anatomy, you're ready to put the petal to the metal!

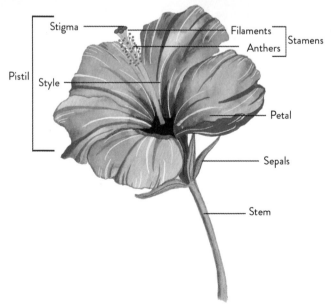

Stigma

Filaments

Anthers

Stamens

Pistil

Style

Petal

Sepals

Stem

Day 10: ROSE

It only seems right to start with the classic rose as our first flower. The rose has been found all over the world throughout history and serves as a universal symbol of love. Known for its full-figured bloom, thorny stems, and wide range of colors, the rose is a beauty. Each flower can have anywhere between 20 and 40 petals arranged in many layers. For this tutorial, we're painting an abstract rose with loose watercolor strokes, starting with a tightly wound center of petals and working our way outward. The placement of each petal is important—as you add each layer of petals, you want to make sure your flower looks balanced.

What You Need

Watercolor Tool Kit (page 14)

Techniques

C curve (page 30)
Boomerang stroke (page 31)
Combination stroke (page 31)
Wet on wet (page 32)
Wet on dry (page 32)

Colors

Permanent rose (1)
Dark green (viridian hue + black ivory) (2)

1 **2**

1. Using your size 4 brush and permanent rose, start painting the center of the rose with a very small C curve that bends like a backward apostrophe **(A)**.

2. Wrap a second apostrophe-shaped stroke around the first one **(B)**. This creates the tight center of the rose.

3. For the second layer of petals, paint three slightly larger petals around the center, using boomerang strokes **(C)**. Aim to keep each stroke separate, and avoid overlapping the petals so that we can use the negative space to differentiate each petal. The petals should not line up or sit right behind each other.

4. For the third layer, paint slightly larger boomerang strokes that wrap around the left side of the rose and under the previous layer of petals just about three-fourths of the entire way around. Keep your strokes loose and wiggle your brush a little as you create the combination strokes to give them organic edges. Repeat this step to paint a petal that encases the right side of the flower **(D)**.

Tip: For balanced composition, do not align the ends of your petals. You always want to place the end of your petal near the center of a petal in the previous layer. Otherwise, your brushstrokes will look more like a concert-seating chart than a flower.

5. For the fourth layer, paint a boomerang stroke that wraps around the top half of the rose. Start the stroke outside of the last petal that you painted in step 4 and move your brush upward. Repeat this step to paint

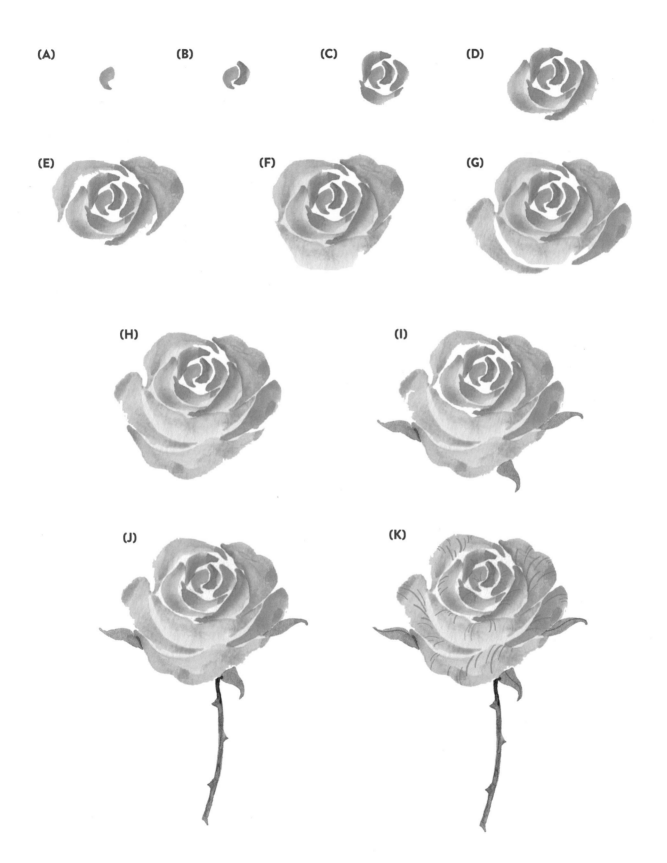

(A)

(B)

(C)

(D)

(E)

(F)

(G)

(H)

(I)

(J)

(K)

the second petal of this layer on the right side of the flower **(E)**.

6. To complete the fourth layer, paint a combination stroke to create one long petal that wraps around the bottom of your rose **(F)**.

7. Add two loose petals that encase the bottom left and right sides of the rose using a combination stroke **(G)**. Leave a small space between the petals at the bottom of the rose.

8. To complete your rose, paint one full peeled-open petal on the bottom using a large boomerang stroke with a rough edge **(H)**.

9. Clean and load your brush with dark green, and paint three sepals peeking out beneath the outer petals, using a combination stroke for each sepal **(I)**.

10. With your size 0 brush and dark green, paint a backward C curve for the stem and add two or three pointy triangles along the stem to make the thorns. With permanent rose and the size 0 brush, touch just the point of the triangles with your brush to add a subtle pink to the tip of the thorns **(J)**. Let the rose dry.

11. Load up your size 0 brush with permanent rose. Add C curves to depict the outward curves of the petals, following the cross-contour lines of each petal **(K)**. The key is to imagine the petals peeling outward and framing the center of the flower. If you split the flower in your view in half, the petals on the left should have backward C curves, and the ones on the right will have C curve lines. Any petals in the center facing us should be split in half and have both types of C curves.

BOTANICAL BONUS: Rosebud

The sweet rosebud can be used as part of a larger illustration. It is small and can be grouped with multiple rosebuds and placed between leaves or behind other flowers. Since a rosebud hasn't bloomed yet, its sepals are upright and tightly hug the petals of the bud.

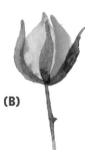
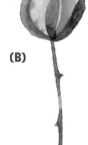
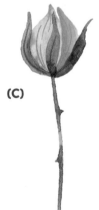

(A)　　　　　**(B)**　　　　　**(C)**

1. With your size 4 brush and permanent rose, paint a teardrop shape and then wrap a second teardrop shape around the right of the original **(A)**. Let the layers dry.

2. Follow steps 9 and 10 above to complete the sepals and stem of the rosebud **(B)**.

3. Add contour detail lines to the rosebud using permanent rose paint and a size 0 brush **(C)**.

Day 11: ANEMONE

The anemone's name is derived from Anemoi, the god of wind in Greek mythology. It's no wonder, as the flower has such a whimsical look thanks to its delicate leaves and deep, gorgeous colors like reds, blues, purples, as well as white. Each layer of the anemone has five to eight over- and underlapping petals that are arranged around a center of black crown-like stamens. Painting white flowers can be tricky, so we'll be using a very light color value of black that looks like a transparent gray. Before starting, dilute your ivory black to create a very transparent gray and your permanent rose paint for a transparent pink.

What You Need

Watercolor Tool Kit (page 14)

Techniques

Wet on wet (page 32)
Wet on dry (page 32)
Lifting paint (page 32)
C curve (page 30)

Colors

Diluted ivory black (1)
Permanent rose (2)
Dioxazine purple (3)
Black purple (ivory black + dioxazine purple) (4)
Sap green (5)

1 2 3 4 5

1. Visualize a circle about the size of a quarter on the center of the paper—this circle will become the center crown and guide the placement of your anemone petals. Feel free to very lightly sketch the circle as a guide, but remember that you won't be able to erase the pencil lines after painting. Using your size 4 brush and diluted ivory black, start at the top of the circle by painting a transparent petal in the shape of a wide, rounded diamond using the full side of your brush. Then, clean your brush, grab some diluted permanent rose, and line the top outer edge of your petal. Switch to dioxazine purple and line the bottom inner edge of your petal while the layer is still wet **(A)**. You should see a very light gradient of pink and bright purple blending into the gray paint. Wait for your petal to dry.

2. Repeat step 1 to create four more petals around your imaginary circle **(B)**. Wait for each petal to dry before moving on to the next one. Make sure that the petals overlap—there shouldn't be any open spaces between the sides of the petals. (Spaces between the bottoms of the petals are fine.)

3. Once all your petals are dry, load your brush with black purple and paint a dime-sized circle inside the larger circle that you visualized in step 1. This circle will fall inside the crown of petals and form the pistil. Create a highlight by using a dry brush to lift up the black-purple paint at the top of your pistil **(C)**. The highlight should take the shape of a downward C curve. Let your layers dry.

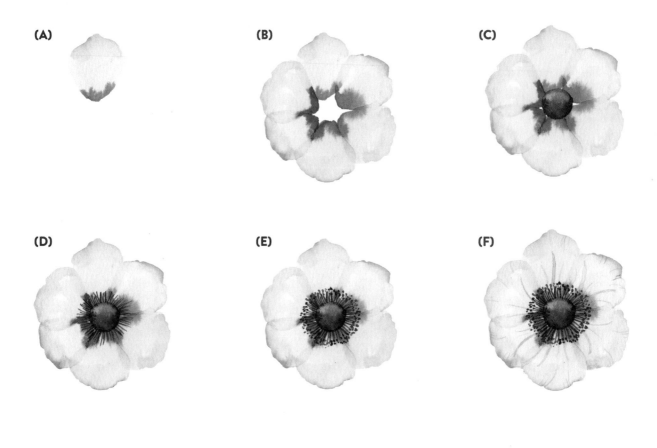

(A) (B) (C)

(D) (E) (F)

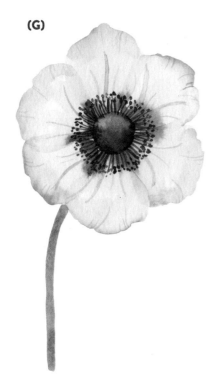

(G)

4. Load your size 0 brush with black-purple paint. Paint a layer of straight, thin lines to create the stamens; start each line from the outer edge of the pistil and move outward. After this first layer of stamens dries, paint another layer. You want the layers of stamens to look very full. Your lines do not have to be the same length—some short and some long ones will make the flower look more realistic. Blend the stamens into the pistil by adding more black-purple paint along the edges of the pistil while avoiding the highlight (D). This will hide the ends of the stamen.

5. Load your size 0 brush with black-purple paint again. Using just the tip of your brush, stamp small ovals at the ends of the stamens for the anthers **(E)**. Let the ovals dry.

6. Load your size 0 brush with a lighter color value of ivory black paint, it should be dark enough to create gray line details. Paint in the contour detail lines, starting from the outer edges of your petals inward and the outer edge of the pistil outward **(F)**.

7. Using your size 4 brush and sap green, finish your anemone by making a loose C curve to paint the stem **(G)**.

BOTANICAL BONUS: Anemone Side View

When painting a floral arrangement or a hillside full of flowers, you'll often want to have alternate views and angles of your blooms. I've always loved the side view of the anemone and seeing the dark pistil peek out from behind a wide petal. Follow these steps to paint the side view of an anemone.

1. Instead of following the shape of a circle from the front-facing point of view, arrange the petals in an oval and on a diagonal. Start by painting a flat petal at the top center of the paper, as you did in step 1 in the tutorial on pages 70, and wrap your second petal around the right of your flower **(A)**. The second petal will have a longer, narrower shape.

2. Add the two bottom petals and align the bottom edges of the petals together at an angle. Then, add a final petal to complete the oval layer of petals **(B)**.

3. Complete the rest of the flower by following steps 3–7 of the tutorial **(C)**.

(A)

(B)

(C)

Day 12: HYPERICUM BERRIES

Berries are both delicious and beautiful, but today we're painting the kind that often show up in flower arrangements and bouquets rather than the ones that show up in a parfait. In fact, hypericum berries are poisonous, so let's definitely keep them out of our desserts. I know the hypericum berry is not a flower, but it is a perfect floral filler, and berries are such a great way to add pops of color to a mix of foliage and florals. Here, we have a sprig of peaches-and-cream hypericum berries, which have a beautiful ombré gradient that shifts from a peachy coral to a light ivory.

What You Need

Watercolor Tool Kit (page 14)

Techniques

Wet on wet (page 32)
Pulling paint (page 34)
Wet on dry (page 32)

Colors

Ivory (burnt umber + Chinese white + a touch of permanent rose) (1)
Coral (cadmium red pale hue + permanent rose + Chinese white) (2)
Burnt umber (3)
Hooker's green dark (4)

1 2 3 4

1. Load up your size 4 brush with ivory paint. Paint a rounded teardrop shape (A).

2. While this layer is still wet, clean your size 4 brush and grab the coral paint. Outline the top half of the berry with the coral paint. Pull the coral paint down into the bottom half of the teardrop (B). Let this layer dry.

3. Load your size 0 brush with the coral. Paint a contour line, moving from the tip of the berry about two-thirds down the right side. Repeat to paint another contour line down the left side (C). These two contour lines create the dips on the surface of the berry.

4. Load your size 0 brush with burnt umber. Paint two tiny curlicues or antennas at the top of the berry (D).

5. Next, you'll add the sepals of the berry. The sepals sit under the berry and open downward to give the berry all the attention. Load your size 0 brush with Hooker's green dark. Starting from the bottom left side of the berry, paint three small, rounded leaflike shapes. Wait for the sepals to dry, then add the C curve midribs of your sepals with the same green (E).

6. Paint the stem using your size 0 brush and Hooker's green dark (F).

7. To finish this little hypericum berry sprig, repeat steps 1–6 to create two more berries, one on each side of the first berry. Tilt both berries slightly so that the bottoms are angled inward toward the middle berry. Connect the bottoms of the stems (G).

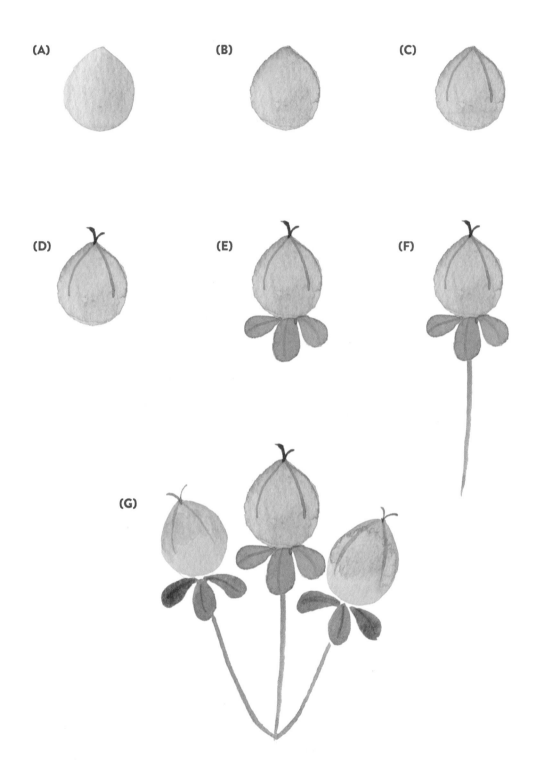

Day 13: FLORAL ARRANGEMENT

It's time to make our first arrangement! I've organized this one into the loose shape of a triangle. It can be used as the subject of a piece, or as an ornamental illustration for an invitation or a hand-lettered quote. When starting an arrangement, you should choose a flower to place in the center and to build the rest of your arrangement around it. Paint your flowers in an alternating pattern to balance the arrangement's colors and shape. We'll start with a rose, build with anemones and more roses, and then add lemon leaves, hypericum berries, and rosebuds. To fill the empty spaces and make the arrangement look fuller, you'll add leaves and floral fillers. Since you're painting flowers that are close to each other, plan to overlap and underlap petals as you build the arrangement.

What You Need

Watercolor Tool Kit (page 14)
Paper cutter or scissors

Techniques

C curve (page 30)
Boomerang stroke (page 31)
Combination stroke (page 31)
Wet on wet (page 32)
Wet on dry (page 32)
Lifting paint (page 32)
S curve (page 31)
Pulling paint (page 34)

Colors

Permanent rose (1)
Dark green (viridian hue +
 black ivory) (2)
Black purple (dioxazine purple +
 ivory black) (3)
Sap green (4)
Viridian hue (5)
Ivory (burnt umber +
 Chinese white + a touch of
 permanent rose) (6)
Coral (cadmium red hue +
 permanent rose +
 Chinese white) (7)
Hooker's green dark (8)

1. With your pencil and ruler, lightly sketch a wide triangle. I drew a 6-inch-wide (15.2 cm) and 2½-inch-tall (6.4 cm) triangle **(A)**. You can also eyeball it if you feel like living on the edge. We'll aim to keep our arrangement in the general shape of this triangle, but remember, it doesn't need to be perfect! We'll have some flirty leaves and fillers poking beyond the borders.

2. Start by painting a pink rose at the bottom center of your triangle using the tutorial on page 68 **(B)**.

3. Add a side-facing anemone on the right of the rose and a front-facing anemone to the left using the tutorials on page 71 **(C)**. Make sure to eyeball where you want to place the center of your anemone before you start painting so that you leave enough space to paint five full petals for each flower. You can also underlap one or two petals beneath the rose to create a feeling of closeness. Each flower should line up with the bottom of the triangle.

4. Wait for your paint to dry, then paint two lemon leaves (page 48) that frame the first rose **(D)**. This will help give the arrangement a more natural look.

5. Paint an additional rose on the top left of the original rose; it should peek out from behind the front-facing anemone. Begin filling the top of

x
1 2 3 4

5 6 7 8

76 **WATERCOLOR** BOTANICALS

the triangle with an anemone, placing it on the top right of the rose **(E)**. Make this anemone peek out from behind the rose painted in this step and the leaf on the right side of the triangle.

6. To finish painting the florals of this arrangement, add a smaller side-facing rose next to the bottom-right anemone **(F)**.

7. Now, it's time to take a second to pinpoint any empty spaces outside of your floral arrangement. Can you see where it would be perfect to add some leaves and fillers? For this piece, try adding two sprigs of lemon leaves on the two corners at the bottom of the triangle **(G)**.

8. Continue adding lemon leaves to the spaces in between the petals and flowers that you painted around and outside of the triangle **(H)**. For variety, paint a full view of some leaves and a partial view of others.

9. Add two hypericum berries (page 74) behind the anemone at the top of the triangle, two more between the rose and anemone at the bottom center, and a single one above the rose at the top left of the triangle **(I)**.

10. Paint a pair of rosebuds near the left angle of the triangle and another pair on the top right side of the arrangement **(J)**.

11. To finish, add any additional lemon leaves to balance out the whole arrangement. You can do so by looking for any remaining open spaces and at the overall triangle shape to make sure the left side and right side have the same weight and balance of leaves and flowers. Don't forget to paint contour detail lines for each flower, berry, and leaf. Erase any visible pencil lines **(K)**.

(A)

(B)

(C)

(D)

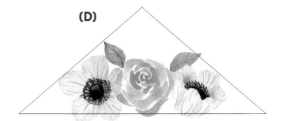

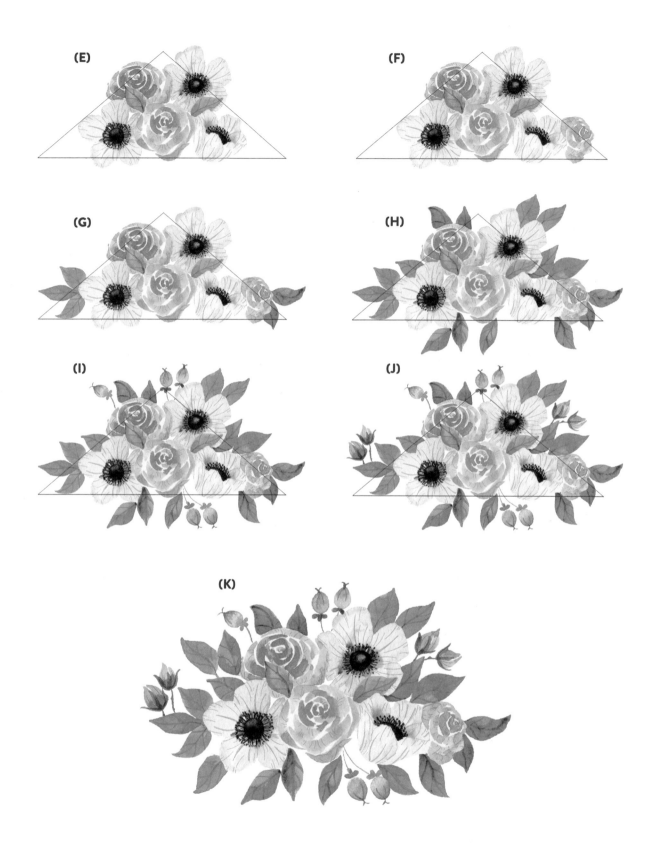

Day 14: PEONY

The peony, which appears exclusively during the end of spring and early summer, is such a special flower. The flower is rumored to be named after Paeon, the physician of the gods in Greek mythology, who used peony root to heal Pluto, the god of the underworld. In China, the peony symbolizes prosperity and wealth. It is also a popular wedding bouquet flower. Here, we're painting the Big Ben peony, which has full, silky cuplike fuchsia petals with rough edges. When the peony is just a wee little bud, the flower forms inside a tight ball that shows the spherical shape of the petals. As the flowers bloom, the petals keep their shape as they open up and outward. Keep this shape in mind as you paint the peony.

What You Need

Watercolor Tool Kit (page 14)

Techniques

Combination stroke (page 31)
Boomerang stroke (page 31)
Wet on dry (page 32)

Colors

Fuchsia (cadmium red deep hue + permanent rose + a touch of dioxazine purple) (1)
Cadmium yellow hue (2)
Hooker's green dark (3)

1 2 3

1. Load your size 4 round brush with fuchsia paint. Start by painting the center ring of petals, which will hug the yellow anthems when you're finished. Using the full side of your brush, paint the first petal at the 12 o'clock position, creating a circle-like shape that has a rough edge along the bottom side, like the jagged edge of a cracked eggshell **(A)**. The rough edge will form the outer edge of the petal. Unlike other flowers with petals that peel completely outward, such as the gerbera daisy (page 96), the peony's cuplike petals hug the center of the flower and create a ball-like shape.

2. Paint a petal at the 9 o'clock position using the combo curved stroke from the top down and adding a rough edge **(B)**. The rough edge of this petal should face the center of the flower. Leave a tiny bit of space between this petal and the previous one. We'll be using negative space to define the form of the peony.

3. Repeat step 2 to paint a third petal at the 6 o'clock position and step 1 to paint a fourth petal at the 3 o'clock position **(C)**. The rough edges of each petal should face the center. These four petals should form a loose circle.

4. Let's start the next ring of petals. Above the top left of the first ring, paint a boomerang stroke with a rough edge **(D)**. Remember, you should stagger the placement of the petals so they are not placed directly behind one another. Make sure to start painting this petal slightly above the 9 o'clock position and end the stroke at the 1 o'clock position.

5. Working counterclockwise, paint the next petal. Start this petal at the 9 o'clock position, just outside of the previous petal added in step 4

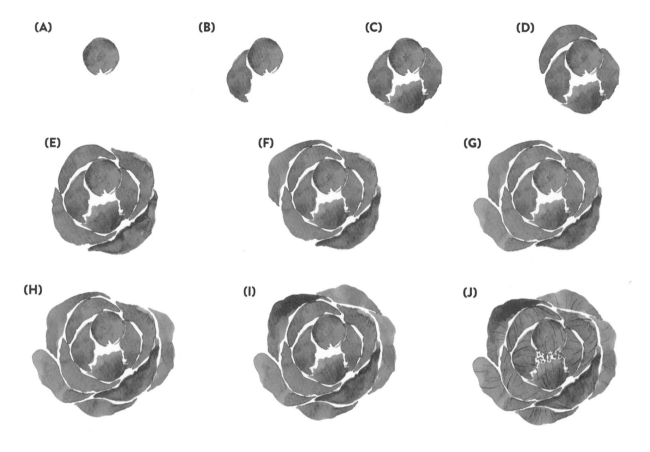

(A) (B) (C) (D)

(E) (F) (G)

(H) (I) (J)

using the boomerang stroke. Bring that stroke around the first ring of petals to the 6 o'clock position. Repeat this step to paint another petal on the opposite side of the first ring, bringing the stroke from the 1 o'clock position to the 4 o'clock position. Finish the second ring of petals with a third petal around the bottom right **(E)**.

6. Start the third layer of petals by using another boomerang stroke to paint a petal that extends from the 9 o'clock position to the 12 o'clock position **(F)**. To give the peony a more natural look, you will begin to pull the petals outward with the center of the petal coming out farther than the previous petals.

7. Paint your next petal with a boomerang stroke, moving from bottom to top, but this time end the petal at the top with a rounded edge **(G)**. The rounded edge should hug the closest petal in the previous layer at the 9 o'clock position. This helps you portray how

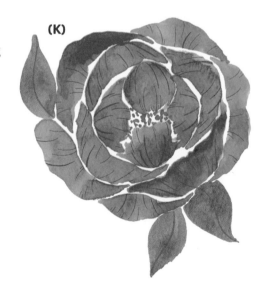

(K)

the outer petals gradually open and give the peony its signature look when it's in bloom.

8. Paint the bottom petal with (you guessed it) a boomerang stroke, pulling the stroke from the 7 o'clock position to the 5 o'clock position. Repeat this step to make the petal on the outer right, moving from the 4 o'clock position up to the 1 o'clock position **(H)**.

9. Complete the peony by painting a petal above the top right of the flower with a boomerang stroke, pulling down from the 12 o'clock to 2 o'clock position **(I)**. Let all your layers dry.

10. With the tip of the size 4 brush, stamp cadmium yellow dots to create the anthems that peek out from the inside of the peony. With the size 0 round brush and fuchsia paint, add the contour detail lines on each petal **(J)**. These lines are key in clarifying where each petal ends and starts and showing how they curl inward or outward. For this peony, the first two rings curl inward, while the outer ring curls outward.

11. Using your size 4 brush and paint Hooker's green dark, paint sepals that peek out from under your full peony. I randomly placed two together, and one on its own. Once dry, don't forget to add the midribs to the leaves using your size 0 brush and Hooker's green dark paint **(K)**.

BOTANICAL BONUS: Peony Side View

The side view of the peony shows off the round, cuplike shape of the flower. As you paint the inner petals, anthems, and the peeled-back petals in the outer ring, it's helpful to keep this shape in mind. Remember to paint the bright yellow anthems that are nestled in the center petals.

1. Simply start painting your inner ring of curled petals following the steps 1–3 of the peony tutorial on page 79 **(A)**.

2. Begin painting a layer of petals that curl outward. This layer will have three petals that fan open **(B)**.

3. When the petals are dry, paint your anthems, sepals, stem, and contour detail lines **(C)**.

(A)

(B)

(C)

Day 15: RANUNCULUS

The ranunculus is part of the buttercup family, and no wonder—it's so darling! With the seemingly infinite amount of delicate, paper-thin petals, the cute round shape of its flower, and its charming crooked stem, it's the perfect star for a larger arrangement and also shines as a supporting flower. The ranunculus symbolizes charm and attractiveness—a perfect choice if you want to tell someone that you're, you know, into them. For this tutorial, we're painting a Persian ranunculus in peach. As we've done with the rose and peony, you'll start painting the center of the flower and continue wrapping additional rings of petals around this center.

What You Need

Watercolor Tool Kit (page 14)

Techniques

Combination stroke (page 31)
Wet on dry (page 32)
C curve (page 30)

Colors

Sap green (1)
Peach (cadmium red pale hue + Chinese white) (2)

1 2

1. Using your size 4 round brush and sap green, paint a small combination stroke in the shape of an apostrophe **(A)**.

2. Paint a mirror image of the combination stroke from step 1 **(B)**. You will wrap this combination stroke around the first stroke. This creates the pistil of your ranunculus.

3. Then, clean and load your brush with peach paint. Using a small combination stroke, paint the first petal, starting from the left of the pistil and wrapping it halfway around the top of the pistil. Use another small combination stroke to paint the second petal under the pistil to complete the first ring of petals **(C)**.

4. Using the combination stroke again, paint an additional ring of petals, with one petal around the left side of the first ring and one petal around the right side. Then paint two additional rings of petals with three petals in each ring **(D)**. Make sure to offset the ends of each petal so that the petals do not start where the petals in the previous ring start.

5. Continue building the ranunculus by adding at least four more rings of petals, using the combo stroke and three or four petals in each layer **(E)**.

(A) **(B)** **(C)**

(D)

(E)

(F)

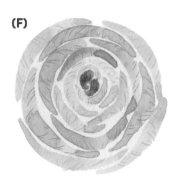

(G)

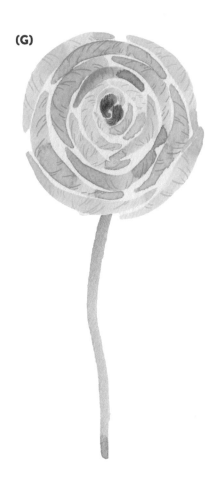

Maintain the circular shape of the flower and place the petals close to each other so that the rings hug each other very closely. Let these layers dry.

6. With your size 0 round brush and peach paint, add C curve contour-line details **(F)**. For the ranunculus, I have all the petals curling inward.

7. Switch to your size 4 brush and load it with sap green. Using consistent pressure, paint a thick stem with a slight kink, starting from the bottom center of the ranunculus and moving your brush down **(G)**.

BOTANICAL BONUS: Ranunculus Side View

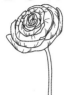 To paint a side view of the ranunculus, you simply build the flower at a diagonal direction and arrange the petals in the shape of an oval instead of a circle. This flower faces our direction slightly, meaning that you'll be able to see the ranunculus's shallow cuplike shape without losing view of the green pistil.

1. Paint a sap green pistil slightly angled to the right to form an oval pistil and build oval petals around the pistil instead of the round ones you made in the tutorial on page 82 **(A)**. You should paint four rings of petals **(B)**.

2. For your fifth and last ring, paint the petals between the 1 o'clock and 9 o'clock positions **(C)**. Don't wrap them completely around the flower.

3. Add C-curve contour detail lines **(D)**. All the petals should look like they're curling inward.

4. Don't forget to paint your stem **(E)**!

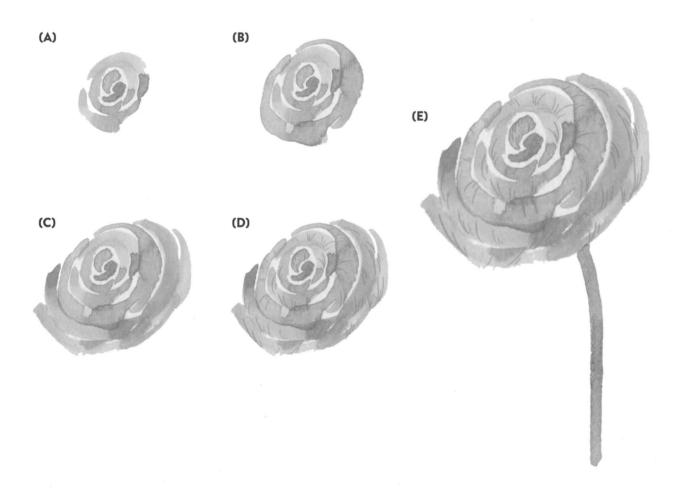

(A)

(B)

(C)

(D)

(E)

Day 16: CRASPEDIA GLOBOSA (Billy Button)

These yellow, fuzzy balls are one of my favorite floral fillers to add to a painting or a real-life bouquet. I mean, just look at them—they scream happy! Part of the daisy family, the craspedia symbolizes good health, and its name comes from the Greek word *kraspedon*, which means "fringed edge." The craspedia has many common names, billy button being one of the most common, because it describes its spherical shape and intricate texture. It is a durable flower, known to dry well if you want to extend its longevity. We're going to paint this little one with all of its attributes!

What You Need

Watercolor Tool Kit (page 14)

Techniques

Wet on dry (page 32)

Colors

Cadmium yellow hue (1)
Yellow ochre (2)
Sap green (3)

1 2 3

1. Load your size 4 brush with cadmium yellow and paint a circle. Start with a small circle and build it outward to refine its shape **(A)**. Let the circle dry.

2. Load your size 0 brush with yellow ochre paint. Use the tip of the brush to make a star-shaped cluster of six dots at the top **(B)**.

3. The details on the billy button's surface are arranged in patterns, so we're going to add them in an organized way. Begin outlining the edge of your circle with the clusters of dots. Place the top dot of each cluster outside the circle to reproduce the fuzzy look of the real-life billy button **(C)**.

4. Paint a vertical line of the clusters to split your circle in half **(D)**.

5. Fill in the left side with the dots, following the center line from the last step and working your way to the outer clusters. Repeat to fill the right side. Painting your clusters in this way will add uniformity to your billy button's textured details. Add additional dots to fill any empty areas as needed **(E)**.

6. Now, you have a cute little billy button! To finish, using your size 4 brush and sap green, simply paint a thick, straight stem from the center of your billy button, moving your brush in one fluid downward motion and keeping the same level of pressure throughout **(F)**.

Day 17: FULL-PAGE FLORAL PIECE

You've learned how to paint the romantic peony, the charming ranunculus, and the darling craspedia. It's time to put them all together in one piece! Do you remember what you learned about the rule of thirds (page 18)? You'll divide your paper into a grid with nine spaces and paint the peonies and ranunculus near the four main focus points in the center of the piece. From there, we'll fill in the center of the paper with ranunculus, and then the outer thirds with our fillers. We'll complete the piece with an indigo watercolor wash for the background.

What You Need

Watercolor Tool Kit (page 14)

Techniques

Combination stroke (page 31)
Boomerang stroke (page 31)
Wet on dry (page 32)
C curve (page 30)
Wet on wet (page 32)

Colors

Fuchsia (cadmium red deep
 hue + permanent rose + a
 touch of dioxazine purple) (1)
Cadmium yellow hue (2)
Hooker's green dark (3)
Sap green (4)
Peach (cadmium red pale
 hue + Chinese white) (5)
Dark green (ivory black +
 viridian hue) (6)
Dark blue green (ultramarine +
 dark green) (7)
Yellow ochre (8)
Gray green (Chinese white +
 viridian hue) (9)
Indigo (10)

1. Let's start by setting up your paper. With a ruler and pencil, measure and mark ½ inch (1.3 cm) from each edge of the watercolor paper. Alternatively, you can simply line your edges with washi tape or painter's tape. You'll be painting in portrait, meaning that the vertical length of your paper is greater than its width.

2. The peonies will be the biggest and brightest flowers, so we'll start here. With your size 4 brush and fuchsia, paint a large front-facing peony using the tutorial on page 79. Place the flower slightly left of the center of the page. Next, using the instructions in the Botanical Bonus on page 81, paint two side-facing peonies on the top left and top right of the first peony **(A)**.

3. Peach ranunculus are a perfect companion for our three peonies. Using the instructions on page 84, paint two side-facing ranunculus in the space between the two side-facing peonies. Orient these flowers diagonally toward corners of the paper. Leave a little space between the ranunculus so that you have room to add sepals and olive leaves later. Surround the bottom of the front-facing peony with three ranunculus **(B)**. I did this by painting two side-facing flowers and one front-facing flower.

(A)

(B)

4. I like to jump to painting the silver dollar eucalyptus leaf (page 54) next because they typically take up a lot of space. Adding these sprigs next will allow us to better visualize where the craspedia and thinner olive leaf sprigs should be added. Place one eucalyptus sprig in between the peony and ranunculus at the top left of the piece, one sprig on the left of the front-facing peony, and one in the space between the two ranunculus at the bottom right of the piece **(C)**. Feel free to run your leaves and stems off your paper. If you're using tape, you can simply paint over that edge, and if you've penciled your border, make sure to carefully keep your paint inside the lines.

5. You'll add the craspedia next because their straight stems and spherical flowers give you less flexibility with their placements. Using steps 1–5 of the tutorial on page 85, paint clusters of two and three billy buttons in the top left, top right, bottom left, and center right edge of your paper **(D)**. Let some sections of the craspedia fall outside the edge of your border. Don't paint the stems yet!

6. The olive leaf (page 52) is our MVP, acting as the final filler to complete this piece. Look for negative spaces that need to be filled, such as the areas between flowers or at the corners of the paper, to paint your olive leaves **(E)**. Don't forget about opportunities for the sprigs to run off the paper. Let all the layers of paint dry.

7. Now that we've painted all of our florals and fillers, take a step back, roll your shoulders and neck, and take a look at your piece. Are there any additional spaces to fill? How is your composition? Does everything look balanced? After thinking about these questions and looking at my piece, I decided to add some sepals under two of my ranunculus. Now, let all of your layers dry.

8. If you're feeling good about your piece, now is the time to add in any additional contour detail lines to the flower petals, sepals, and leaves, and also the stems for the billy buttons **(F)**.

(C)

(D)

(E)

(F)

9. Then, using a light color value of indigo, paint the remaining negative spaces **(G)**. I've used the wet-on-dry wash technique to carefully navigate around the botanicals to fill the background. If you used washi tape, peel off the tape from the edge of the paper. If you used pencil, erase the lines where you can. You did it! Great job, friend!

WATERCOLOR BOTANICALS

Day 18: TULIP

The sweet tulip, with its silky, shiny leaves, gives any shampoo commercial a run for its money. It's a great flower for every occasion, available in so many colors and often in multicolor varieties. They can hold meanings tied to their colors, like red for romance, white for forgiveness, and purple for royalty. Tulips have been seen as a symbol of perfect or deep love after making an appearance in a Turkish love story starring a prince and a princess. Here, we'll be painting variegated red-and-yellow tulips.

What You Need

Watercolor Tool Kit (page 14)

Techniques

Wet on wet (page 32)
Combination stroke (page 31)
Wet on dry (page 32)

Colors

Cadmium yellow hue (1)
Rose madder hue (2)
Sap green (3)

1 2 3

1. Using your size 4 brush and cadmium yellow hue, start painting the tulip's center petal with the full side of your brush. Round the bottom of the petal and paint a rough edge at the top **(A)**.

2. While the yellow paint base is still wet, load your brush with rose madder and line the bottom half of the petal's edge, then blend the rose madder about three-quarters of the way up the petal, leaving the tip of the petal yellow **(B)**. Let this petal dry.

3. Using cadmium yellow, paint the right petal that is barely in view with a narrow combo brushstroke. Start the brushstroke at the right of the first petal's base and keep the stroke in line with the edge of the first petal so that you maintain the flower's tubelike shape. Blend in rose madder, starting at the bottom of the petal and working three-quarters of the way up the petal. Repeat this step to paint the left petal **(C)**. Let these petals dry.

4. Using the cadmium yellow, paint a very slim petal peeking out from behind the center petal with a thin combo stroke **(D)**. Make sure to roughen the top edge. Let this last petal dry.

(A) **(B)** **(C)** **(F)**

(D) **(E)**

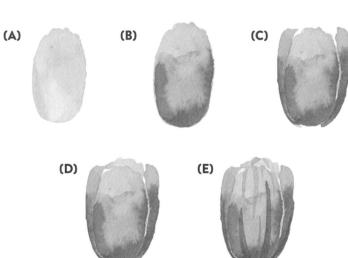
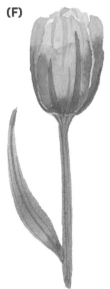

5. Now it's time for the details! With your size 0 brush and rose madder hue, paint thick contour detail lines on the center petals, starting on the bottom of the petals and moving up. With your size 0 brush and cadmium yellow, add additional lines, starting from the top edges of the tulip and moving down **(E)**.

6. Using your size 4 brush and sap green paint, create a thick, straight stem, starting from the center of the tulip's base and moving down, using consistent pressure all the way. With the combination stroke, paint a long, thin leaf on the left of the stem. Once this layer is dry, add your contour detail lines to your stem and leaves **(F)**.

BOTANICAL BONUS: Tulip Side View

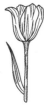 One of my favorite things about the tulip is its simple, upright petals, which open gradually over time. As the tulip blooms, the petals you typically imagine when you think of a tulip start to open outward, and the top edges of the petals begin to bend slightly. As it continues blooming, it begins to reveal its center and pistil! In this botanical bonus, we'll be painting the blooming tulip with its leaves opening and bending, just like nature's kiss.

1. For this first left petal, instead of painting it as a somewhat straight combo stroke, paint a combo stroke in the shape of a backwards S to show the top of the petal curling outward. Follow step 2 of the tulip tutorial (page 91) to blend the rose madder into the cadmium yellow **(A)**.

2. The next two petals will be similar to the ones we painted in steps 1 and 3 of the tulip tutorial **(B, C)**. Paint the very right petal with more of a bend toward the right.

3. Fill in the space between the first and second petal with a layer of cadmium yellow and wet on wet lined with rose madder to paint a glimpse of the petal on the other side of the flower **(D)**.

4. Add contour detail lines to each tulip petal **(E)**.

5. Paint the stem and leaf using sap green. Add contour detail lines once the initial layers are dry **(F)**.

(A) **(B)** **(C)** **(F)**

(D) **(E)**

Day 19: ICELANDIC POPPY

With the papier-mâché thinness and the slightly pleated surface of its petals, and its crooked and twisted stem, the poppy always melts my heart, especially when I imagine a field of them swaying on a hillside in the wind. The poppy is known as a symbol of dreams. No wonder it's my go-to whimsical flower! Today, we'll paint a front-facing blue Icelandic poppy, which represents imagination and success—it's perfect for this book! As you paint, consider how the poppy's petals come together to create a bowl shape, and pay attention to the little peaks of the petals' edges, which indicate whether the petal is folding inward or outward.

What You Need

Watercolor Tool Kit (page 14)

Techniques

Boomerang stroke (page 31)
Combination stroke (page 31)
Wet on dry (page 32)
S curve (page 31)
C curve (page 30)

Colors

Sap green (1)
Cerulean blue hue (2)
Cadmium yellow hue (3)
Cadmium red pale hue (4)
Hooker's green dark (5)

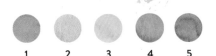

1 2 3 4 5

1. Using your size 4 brush and sap green, paint a small circle **(A)**. This will be the poppy's pistil. Let it dry.

2. Using cadmium yellow hue, paint a circle around your pistil **(B)**. This is the ring that supports all the stamens around the pistil. Let this layer dry.

3. Like the anemone (page 71), you'll paint the top center petal first. Using your size 4 brush loaded with cerulean blue hue, paint a diamond-shaped petal using the boomerang stroke **(C)**. Leave the edges of petal jagged and rough.

4. Working clockwise and using a combo stroke, paint another petal with the same diamond shape. Poppy petals are thin and crinkly; don't forget to roughen the edges. Repeat the same shape to create the bottom and left petals **(D)**. Let all the petals dry.

5. Using your size 0 brush, paint a cadmium red pale hue flower shape with five petals on the sap green pistil **(E)**. This is the ovary of the poppy.

6. Using cadmium red pale hue, paint slightly curved stamens around the pistil, alternating their lengths to make them look more natural. Using the tip of your size 0 brush, stamp cadmium red pale hue dots along the ends of the stamens to create the anthems **(F)**.

7. Now, you'll add details that give the poppy petals depth and a sense of natural movement. First, using your size 0 brush and cerulean blue paint, you'll paint S curves near the outside edge of each petal that show where the outer edge of the petals curl inward. Using my outline sketch on this page as a reference, create these S curves on each petal. For the right petal, add two of these curves, one near the 12 o'clock position of the petal

and one at the 3 o'clock position. Next, outline the edge of each petal with cerulean blue hue, making sure to follow the rough edges. Then, it's time for the contour detail lines. Use C curves to paint the contour detail lines on the side of the petals facing us and the lines on the parts of the petal curling inward **(G)**.

8. With your size 4 brush and sap green, paint an off-center stem to the right that curves and looks crooked because of the weight of the flower head **(H)**. Use consistent pressure as you paint.

9. Using the tip of your size 0 brush and sap green paint, add tiny and thin upward C curves along the stem **(I)**. In the future, you can choose whether you want to leave this hairy feature off of your Icelandic poppy paintings.

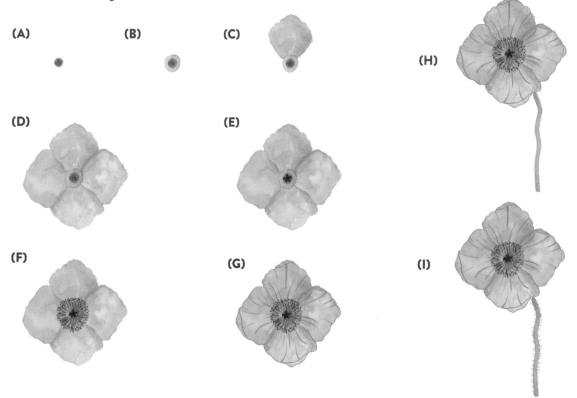

(A) **(B)** **(C)** **(H)**

(D) **(E)**

(F) **(G)** **(I)**

BOTANICAL BONUS: Icelandic Poppy Side View

The side view of this delicate flower is just as much fun as the front-facing view and shows the bowl-shaped silhouette of the flower. The petals will fold outward, giving the poppy a charming look. We'll also add a sweet little bud with a drooping stem, the perfect extra detail. You'll use the same paint colors you used for the Icelandic poppy tutorial plus Hooker's green dark.

1. With a side-facing poppy, one full petal will be in view; this petal will also be curling outward toward you. With your size 4 brush and cerulean blue hue, paint a diamond-shaped petal following step 3 of the Icelandic poppy tutorial (page 93), but make the top of this petal flatter **(A)**.

2. Using a boomerang stroke, paint the left petal, wrapping the bottom end of the stroke around the first petal **(B)**.

3. Repeat step 2 to paint a petal on the right side. Extend the top left of the right petal with a thin combo stroke that wraps around the top edge of the right petal and meets the side of the middle petal **(C)**.

4. As you did in the Icelandic poppy tutorial, use your size 0 brush, cerulean blue hue, and my outline as a guide to paint S curves along the top left edges of each petal to show that the petals curl outward **(D)**.

5. Paint a straight stem with your size 4 brush and sap green paint using consistent pressure **(E)**. Using your size 0 brush and sap green, paint the hairs for the stems with upward C curves.

6. Next, you'll add the stem that connects to the bud. Using a size 4 brush and sap green paint, place your brush just right of the stem's bottom and paint an upside-down U . This stem should be a little thinner than the first one. Paint an oval at the end of the stem with sap green **(F)**. This is the bud.

7. Next, using your size 0 brush and Hooker's green dark, outline the bud, and paint a loose backward C curve down the center of the bud. At the base of the bud, paint into the end of the stem very slightly. Add some light and short C curves and backward C curves at the base of the bud **(G)**.

8. Add hairs on the curved stem and the bud with alternating upward and downward C curves **(H)**.

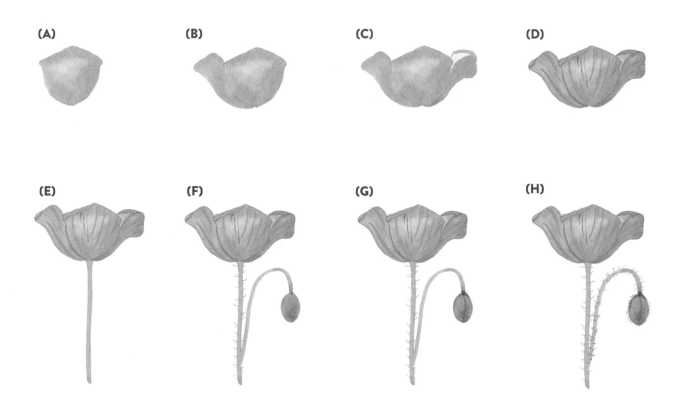

(A)　　　(B)　　　(C)　　　(D)

(E)　　　(F)　　　(G)　　　(H)

Day 20: GERBERA DAISY

The gerbera daisy is the fifth most popular cut flower in the world, behind the rose, chrysanthemum, carnation, and tulip. This isn't surprising considering the gerbera daisy's beaming colors and happy disposition. It represents cheerfulness, innocence, and purity. With layers of petals that vary in length, it makes a full and colorful touch to any bouquet (or painting)!

What You Need

Watercolor Tool Kit (page 14)

Techniques

C curve (page 30)
Combination stroke (page 31)
Wet on dry (page 32)

Colors

Burnt umber (1)
Cadmium yellow hue (2)
Permanent rose (3)
Sap green (4)

1 2 3 4

1. With your size 4 brush and burnt umber, paint a downward C curve. Close the shape with a loose upward C curve **(A)**. This creates a rounded, football-shaped pistil. Let it dry.

2. With cadmium yellow hue, paint an oval around your pistil **(B)**. Make the top of the oval thinner than the other sections. Let this layer dry.

3. Now, it's time for your petals. With permanent rose, paint a single petal above the pistil using two straight combination strokes. The strokes should meet in the center and at the tips to create a single petal. From here, work clockwise and paint additional petals, starting from the top of the pistil and fanning open around the right side. At about the 2 o'clock position, begin to paint petals with a combination stroke in the shape of a downward C curve and straighten out the petals gradually as you get down to the 6 o'clock position **(C)**. Angle your petals like the hands of a clock as you move around the pistil.

4. Repeat step 3 to add petals on the left side of your flower and mirror **(D)**. Wait for the petals to dry.

5. You will now paint a second layer of petals. Repeat steps 3 and 4 to paint more petals around the daisy, but this time, make sure to place your petals in between the spaces in the first layer of petals. Overlap the previous layer of petals to create a complete and full daisy **(E)**. Wait for the second layer of petals to dry.

(A) **(B)** **(C)**

6. Paint a ring of tiny petals around the yellow section of the pistil. Use just the tip of your brush to stamp the small petals **(F)**.

7. Using your size 0 brush and burnt umber, begin dotting the center pistil to add texture **(G)**.

8. Repeat step 7 to add dots of permanent rose to the yellow section of the pistil **(H)**.

9. Using a size 0 brush and permanent rose, paint detail lines along the center of your petals **(I)**. Make sure to follow the contour of each petal.

10. To finish your daisy, use your size 4 brush and sap green to paint a straight stem extending from the center of your daisy **(J)**.

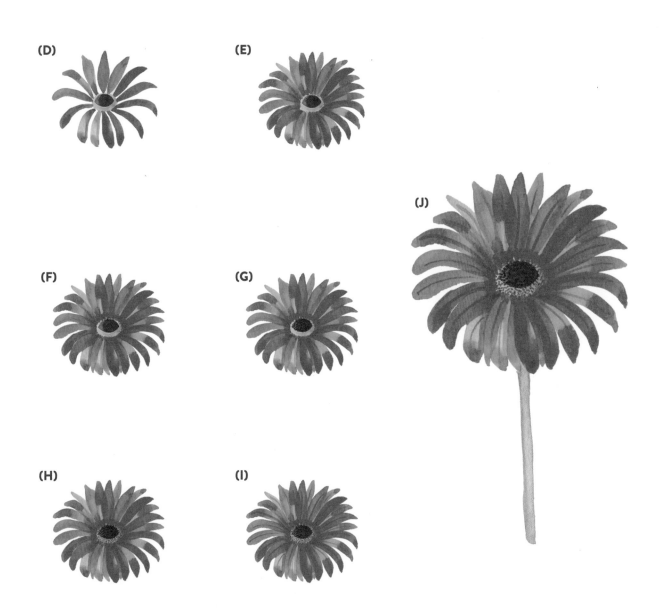

(D) (E) (F) (G) (H) (I) (J)

BOTANICAL BONUS: Gerbera Daisy Side View

 You've covered the top view of the gerbera daisy. The next challenge is to paint the side view. I love when we get to paint the underside details of flowers since we don't see them as often. This side view of the gerbera daisy shows off its crown-like sepals.

1. Using your size 0 brush and sap green, paint the stem and a crown-shaped cup for the sepals of the daisy **(A)**.

2. Using your size 0 brush and permanent rose, paint a petal with a combo stroke under the first sepal on the left **(B)**.

3. Continue painting petals in between the sepals, shortening them as you approach the center **(C, D)**. Fan the petals out toward the left.

4. When you reach the center, paint a straight combo stroke for the centermost petal. As you continue painting petals, fan them out toward the right **(E)**.

5. Using your size 0 brush, paint your contour detail lines on your petals and stem with permanent rose for the petals and sap green for the stem **(F)**.

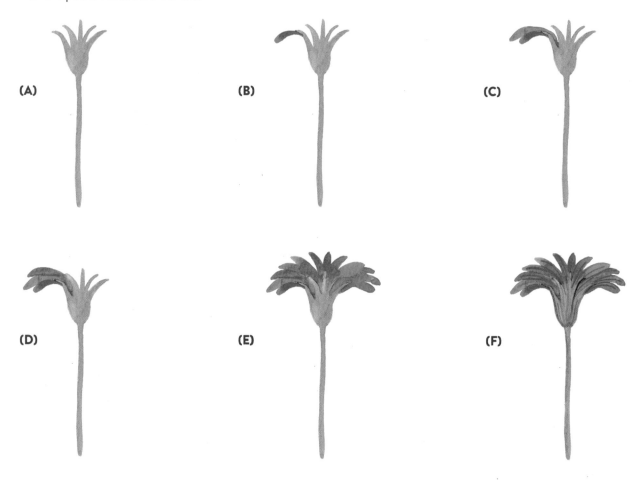

(A)

(B)

(C)

(D)

(E)

(F)

Day 21: FLORAL FLAT LAY

You just learned how to paint three colorful flowers, so let's put them together in a single-stem flat lay. I love that the stems of these three flowers stems are so distinctive, making them a perfect trio to paint in one piece. This piece will give you the chance to practice what you learned in the previous three tutorials and to try adding a little personality to each flower. This piece will be in landscape, and we'll evenly space the three flowers across the paper.

What You Need

Watercolor Tool Kit (page 14)

Paper cutter or scissors

Techniques

Wet on wet (page 32)

Combination stroke (page 31)

Wet on dry (page 32)

S curve (page 31)

C curve (page 30)

Colors

Cadmium yellow hue (1)

Rose madder hue (2)

Sap green (3)

Cerulean blue hue (4)

Cadmium red pale hue (5)

Permanent rose (6)

1. Measure your paper and cut it into an 8 x 10-inch (20.3 x 25.4 cm) sheet. Orient the paper in landscape. With a ruler and pencil, measure and mark ½ inch (1.3 cm) from each edge of the paper. Make another mark at the center of your paper at the top and bottom, 5 inches (12.7cm) from the left and right sides. This will show you the vertical center of the paper.

2. You will place a red-and-yellow tulip right at the center of your piece. Using the pencil marks as reference and the Botanical Bonus tutorial on page 92, paint a blooming tulip, using a slightly backward C curve for the stem. Don't forget to add a leaf!

3. Using the tutorial on page 93, paint a front-facing Icelandic blue poppy on the right of the tulip. Place the pistil at the same level as the petals of the tulip so that the two are even. Poppy stems are bendy and unpredictable, so add a little twist to yours. Remember to paint a bud as well. The end of the stems should be in line with each other, so align your poppy stem with your tulip stem.

4. Using the tutorial on page 96, paint a pink gerbera daisy to the left of the tulip with a slightly curved stem. Start with your pistil along the same height as the pistil of your poppy. Align the stem of the daisy with those of the tulip and poppy.

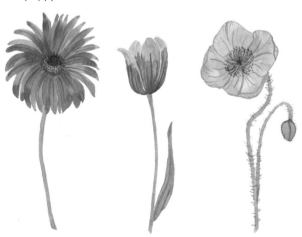

Tropical Plants

With their glossy and bright-colored leaves and florals, tropical plants can light up any room and remind you of frolicking along sandy beaches and vacationing in paradise! From classic palms to peculiar-looking specimens like the monstera, these plants give us the sudden, undeniable need to put on sunglasses and make a fruity, frozen drink to match our moods! Most tropical plants originate in jungles and live their best lives in humid and warm environments, but they can also thrive in indoor settings. I've chosen some of my favorite tropical plants for their unique features, colorful characteristics, and major tropical vibes. Let's paint!

Day 22: MONSTERA

Commonly known as the Swiss cheese plant because of the unique placement of holes and splits on its leaves, *Monstera deliciosa* has become an incredibly popular plant, coveted by many plant lovers. The monstera grows large, elongated heart-shaped leaves with the said holes and splits and gets the "monster" in its name from its ability to grow more than 30 feet (9.1 m) tall in its natural environment. If placed in an environment where it thrives, it can grow petioles that point in all different directions with an abundance of glossy leaves. As you know, we avoid using pencil for most projects, but for the monstera and its uniquely shaped leaves, I recommend starting with a sketch.

What You Need

Watercolor Tool Kit (page 14)

Techniques

S curve (page 31)
C curve (page 30)
Wet on wet (page 32)

Colors

Dark green (ivory black +
viridian hue) (1)

Dark blue green (ivory black +
viridian hue + ultramarine) (2)

Opaque white (3)

 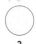

1 2 3

1. With your pencil, lightly sketch a midrib by drawing a very loose S curve **(A)**. As with all of our midribs, you'll use this as the center anchor of the leaf.

2. As mentioned earlier, the monstera leaf is shaped like an elongated heart. To create this shape, sketch a downward C curve starting from the top of the midrib. Pull your line down the left side of the midrib and meet the end of the midrib to create a point **(B)**. Repeat to draw the right side **(C)**.

3. To draw the splits in the leaf, first observe how the edges of each split meet the edges of the leaf at an angle. Starting at the top left of the leaf, sketch an elongated teardrop shape **(D)**. This is where your first split will begin. To make the leaf look more realistic, pull out the points at the bottom of the split so that it extends slightly past the heart-shaped outline.

4. Move down the outline of the leaf and continue to sketch in narrow, rounded splits **(E)**. As you make your way down the side of the leaf, gradually point the splits downward. Make some splits narrow and others wider. Once you make it to the bottom of the leaf, the tip of your leaf should look like half the point of a heart.

5. Repeat step 4 to add splits to the right side of the leaf **(F)**. Take note that the placement of the splits on each side does not need to match as the monstera leaf is not symmetrical. Make some splits larger and some smaller than the ones on the left side to create a more realistic look.

6. Pencil 2–4 oval-shaped holes near the midrib **(G)**. The holes should be arranged diagonally and placed near the rounded ends of each split.

7. Erase any extra pencil lines between the splits and lighten the pencil lines that you will use as painting guidelines so that as little pencil is visible as possible in the finished painting **(H)**.

8. Now that you have finished a sketch, you will begin painting using wet-on-wet blending. With your size 4 brush and dark green paint, fill in the pencil outline with paint starting at the top left of the leaf. While this base layer of dark green is still wet, blend the top edge of each split with dark blue green, working one split at the time **(I)**. This blending will add shading and depth to the leaf. Let the leaf dry.

9. Using your size 0 brush and dark green, paint the midrib. To add the veins of the leaf, paint loose S curves, starting from the midrib and extending it all the way to the edge of the leaf **(J)**. Follow the shape of each individual section of the leaf and avoid painting veins through the holes by placing the veins above or below them. Let this layer dry.

10. Using your size 0 brush and opaque white paint, add contour detail lines, some extending from the edges of your leaf, some extending from the midrib, and some that sit inside the leaf. Follow the shape of the holes and splits of the leaf **(K)**.

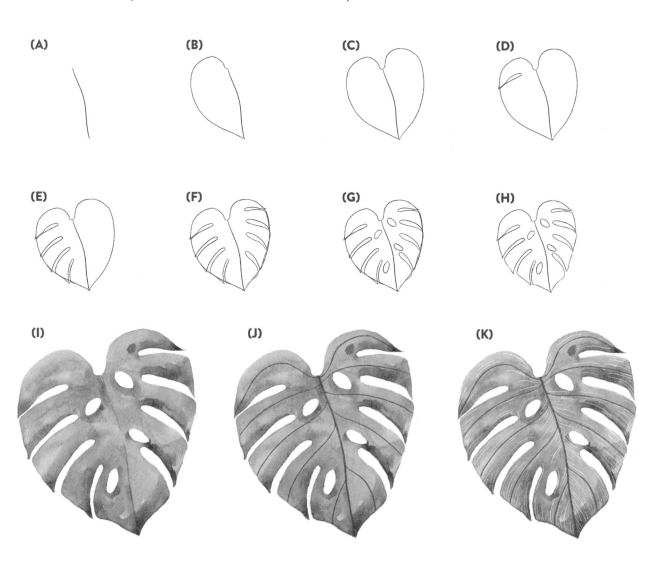

(A) **(B)** **(C)** **(D)**

(E) **(F)** **(G)** **(H)**

(I) **(J)** **(K)**

PROJECT: The Magnified Monstera

You'll create a close-up of the monstera leaf. The edges of the leaf will run off the borders of your paper.

What You Need

Watercolor Tool Kit (page 14)

Techniques

C curve (page 30)
Wet on wet (page 32)
S curve (page 31)

Colors

Dark green (ivory black + viridian hue) (1)
Opaque white (2)
Dark blue green (ivory black + viridian hue + ultramarine) (3)
Permanent rose (4)

 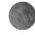

1 2 3 4

1. Measure and cut an 8 x 10-inch (20.3 x 25.4 cm) piece of watercolor paper. Tape the edges with washi tape or painter's tape. Alternatively, you can sketch borders and, when painting, carefully stay within your border lines.

2. Start with a monstera leaf sketch. Begin with the midrib and draw a loose C curve that runs from the top right corner of the paper to the bottom left corner **(A)**.

3. The dip in the heart-shape leaf will begin about 2½ inches (6.3 cm) down from the top right end of the midrib. Sketch the heart shape beginning at this point; the tip of the shape should meet the end of the midrib that is at the bottom left corner of the paper. Remember, this is an up-close view of your monstera leaf, so parts of the shape will fall outside the border of the painting. Erase the top right section of the midrib line that is no longer inside the leaf **(B)**.

4. Begin lightly sketching the splits and holes on both sides of the leaf. Add some splits that run outside of the frame. Lighten your pencil marks, but make sure they are still be visible so that you can use them as a guide for your painting **(C)**.

5. Using your size 4 brush and dark green, paint your leaf following steps 9–10 of the monstera leaf tutorial (page 103), but this time, use opaque white for the leaf veins and midrib and dark blue green for the contour details **(D)**. Let your layers dry.

6. Paint your background with a permanent rose wash to complete the piece **(E)**. Show it off to your friends!

(A)

(B)

(C)

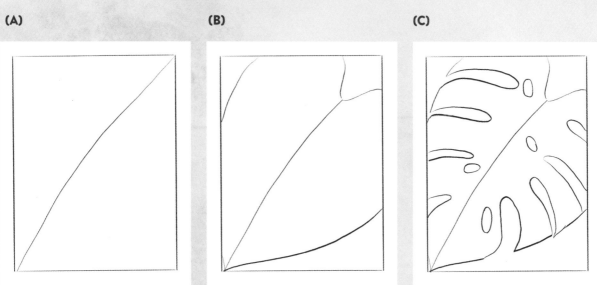

(D)

(E)

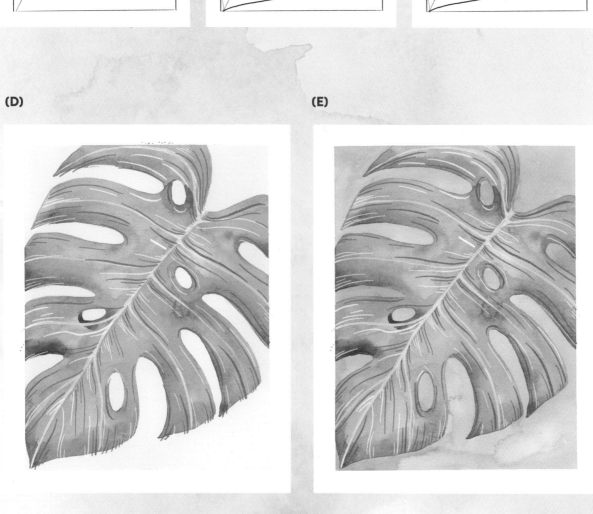

Day 23: BIRD-OF-PARADISE

The bird-of-paradise plant definitely has one of the world's most peculiar-looking flowers, which resembles the head, beak, and colorful crown of an exotic bird. (Coincidentally, they are also pollinated by sunbirds.) The plant is a universal symbol of paradise, as it flourishes best in any sunny and warm environment, and it represents faithfulness and love. Its flower has upright orange sepals and three blue petals that emerge from a green, blue, and red canoe-shaped sheath called a spathe. This tutorial will feature the bird-of-paradise flower and two leaf views. You'll be using plenty of combination strokes to create the spathe, seals, and petals, as well as wet-on-wet blending to add depth of color to each part of the flower.

What You Need

Watercolor Tool Kit (page 14)

Techniques

C curve (page 30)
Wet on wet (page 32)
Combination stroke (page 31)
Glazing (page 41)

Colors

Hooker's green light (1)
Cadmium red pale hue (2)
Rose madder hue (3)
Ultramarine (4)
Dark green (ivory black + viridian hue) (5)

1 2 3 4 5

1. Using your size 4 brush and Hooker's green light, paint the stem using just the tip of your brush and building with light pressure to create it **(A)**. The stem should be straight, about an inch (2.5 cm) long, and the ends should be angled. Let it dry.

2. With cadmium red pale hue, paint the neck of the flower. Start with a rounded, angled brushstroke and shape the top end with a C curve **(B)**.

3. For the spathe, the pointy beak of the flower, paint a very elongated teardrop in Hooker's green light, starting your brushstroke in the convex end of the neck and ending with a fine point. While this layer of paint is still wet, line the top of the spathe with ultramarine and then paint a rose madder hue bump above the ultramarine line **(C)**. The rose madder hue bump should taper off when you reach the end of the spathe. You should see some blending of the three colors within the spathe.

4. To paint the first sepal, load your brush with cadmium red pale hue. Starting where the red in the top edge of the flower neck ends, paint a round, angled combination stroke that points to the left at the 9 o'clock position **(D)**. This creates the first sepal. Feel free to thicken this sepal with another combo stroke.

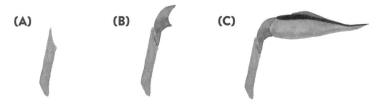

(A) **(B)** **(C)**

(D)　　**(E)**　　**(F)**

(G)　　**(H)**　　**(I)**

5. For the second sepal, paint a straight combination stroke on the right of the first sepal; this sepal will point upward at the 12 o'clock position. Paint another combination stroke for the third sepal, which will point at the 2 o'clock position. For the last sepal, which will peek out from behind the first sepal, paint a combination stroke and angle down at 8 o'clock **(E)**.

6. For the blue petals, use your size 0 brush and ultramarine to paint three straight lines, one each at the 11 o'clock, 1 o'clock, and 3 o'clock positions. Place each line in between each pair of sepals **(F)**.

7. Using the tip of your brush and ultramarine, paint a lip that starts close to the base of each petal and thins out toward the tips of the petals, and fill in the lip **(G)**. You have now finished painting the base layer of the bird-of-paradise flower.

8. Using your size 0 brush and cadmium red pale, paint the contour lines for the red-orange sepals **(H)**.

9. With your size 4 brush and Hooker's green light, use the glazing technique to add shading to the bottom half of the spathe and the right side of the stem **(I)**. Blend with water as needed. Let this layer dry.

10. Using your size 4 brush and dark green, paint angled contour lines to give the stem a cylindrical shape and horizontal contour lines on the spathe. Using your size 0 brush and cadmium red pale hue, paint the contour lines on the flower's neck **(J)**.

(J)

PROJECT: Bird-of-Paradise Leaves

The bird-of-paradise's leaves are a perfect complement to the plant's unique flower. The thick paddle-shaped leaves are a sight to see. You'll typically find them growing in a perfect fan formation. Their waxy green blades are fully intact or split along the leaf veins due to weathering and age. Here, you'll learn how to paint a top view of a solid leaf and a side view of a split leaf.

SOLID LEAF

What You Need

Watercolor Tool Kit (page 14)

Techniques

C curve (page 30)
Wet on dry (page 32)
S curve (page 31)
Pulling paint (page 34)

Colors

Hooker's green light (1)
Opaque white (2)

1 2

1. Using your size 4 brush and Hooker's green light, paint a very loose C curve for the leaf's midrib **(A)**.

2. Next, paint the left blade of the leaf, which will be wider at the bottom and come to a rounded point at the top. Repeat to paint the right side of the leaf **(B)**. Let this layer dry.

3. Once the base of your leaf is dry, use your size 0 brush and opaque white to begin painting thin S curves to create the curved leaf veins. Space them closely, one after another, starting from the bottom of the leaf and working your way to the top on both sides **(C)**. Let this layer dry.

4. Repaint the midrib with opaque white. Blend the white into the stem by wetting your brush and pulling the white paint into the stem **(D)**.

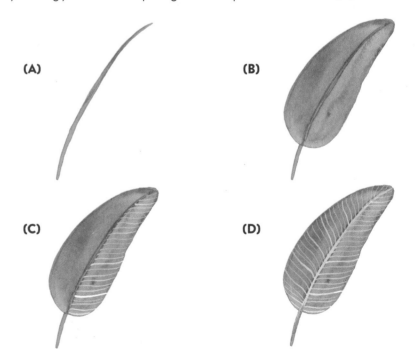

(A) **(B)**

(C) **(D)**

SPLIT LEAF

1. Paint a C curve for the midrib with your size 4 brush and Hooker's green light **(A)**.

2. Start painting the first section of the leaf, which will be on top of the midrib and covers the bottom third of the midrib, using the full side of your brush. Shape the edge with the tip of your brush. End the section by angling and tapering the top right edge of the leaf into a point **(B)**.

3. Repeat step 2 to paint the next section of the leaf. Place this section near the end of the first one **(C)**. This section should extend two-thirds of the way up the midrib.

4. For the last section of the leaf, using medium to light pressure, gradually pull the paint to the tip of the midrib **(D)**. Let the paint dry.

5. Use your size 0 brush and opaque white to add loose S curves to the leaf sections **(E)**. The curves should follow the shape of each section. Let this layer dry.

6. Use Hooker's green light to repaint the midrib and clean up any white lines that may have run over the midrib **(F)**.

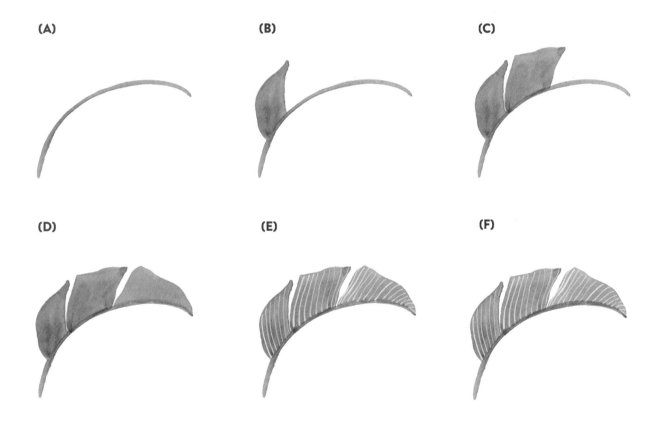

(A)　　　　　　　**(B)**　　　　　　　**(C)**

(D)　　　　　　　**(E)**　　　　　　　**(F)**

Day 24: FAN PALM

Being born and raised in California, I've grown up surrounded by the fan palm. They line famous streets in Hollywood and grace almost every skyline in sight. I just love them! They also happen to be incredibly fun to paint, and a single frond can make a perfect bold accent in a botanical arrangement. A fan-palm frond looks exactly as it sounds—like a fan with folded ridges in the center of each segment. You'll be painting a fan palm with straight segments and a little bend at the ends to show movement.

What You Need

Watercolor Tool Kit (page 14)

Techniques

Combination stroke (page 31)
Wet on dry (page 32)
S curve (page 31)

Colors

Dark blue green (ivory black + viridian hue + ultramarine) (1)
Dark green (ivory black + viridian hue) (2)

1

2

1. With your size 4 brush and dark blue green, paint a short, straight stem (**A**).

2. Paint a straight, upward combination stroke, starting from the top of your stem and ending by gently lifting your brush to create a thin point (**B**). This is the first segment of your fan palm.

3. The segments to the right of the first one will start from the same center point: the spot where the top of the stem meets the bottom of the first segment. Use the same combination stroke described in step 2 for each one (**C**). Make sure to slightly overlap your next segment over your first one.

4. Continue adding more segments down the right side of the leaf. The length of each segment will generally follow the outline of a circle. After adding a couple segments, begin to curve the end of every other segment (**D**). If you're looking at your fan palm like a clockface, start angling the ends of the segments in a diagonal direction and have them point toward the bottom corners of your paper once you reach the 4 o'clock position. Remember to always start each segment at the same center point or else you might begin painting a different kind of palm frond. You do not have to wait for each segment to dry before painting the next. You'll define each segment in step 6.

5. Repeat steps 3 and 4 to add segments to the left side of your fan palm (**E**). Let the segments dry.

6. You'll now paint the "shadow" on each segment. This will create depth and show that there is a fold in the center of each segment. Using your size 0 brush and dark green paint, simply outline the left side of the left segments and the right side of the right segments (**F**).

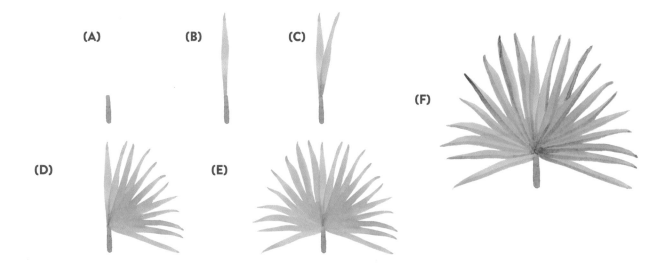

(A) **(B)** **(C)** **(F)**

(D) **(E)**

BOTANICAL BONUS: Fan Palm Side View

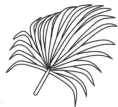

When viewed from the side, the leaves of the fan palm look softer and more slack, so you'll see the ends of the segments bend. This best represents the fronds that you'll see on a fan palm tree swaying in the sunset. We'll be angling the fan palm so that it faces slightly to the left. The segments will follow an oval shape instead of a circle.

1. Using your size 4 brush and dark blue green, paint a straight thick stem, tilted slightly to the right **(A)**.

2. Paint the first segment with the combo stroke, following the same diagonal as the stem. At the very tip of the segment, turn your brush slightly to the right and lift it to create a bend at the tip **(B)**.

3. Following steps 3 and 4 of the fan palm tutorial (page 110), paint overlapping segments on the left side of the palm, bending the tip of each one. When you're two-thirds of the way down the left side, switch the direction of the bend so that it faces the bottom left **(C)**.

4. Repeat step 3 to paint the right side of the fan palm. When you're two-thirds of the way down the right side, switch the direction of the bend so that it faces the bottom right **(D)**.

5. Lastly, using your size 0 brush and dark green, paint the shadows as you did in step 6 in the fan palm tutorial, but place the shadow on the right side of each segment whose tip bends to the right. Place the shadow on the left side of the segments whose tips bend to the left **(E)**.

(A) **(B)** **(C)** **(D)** **(E)**

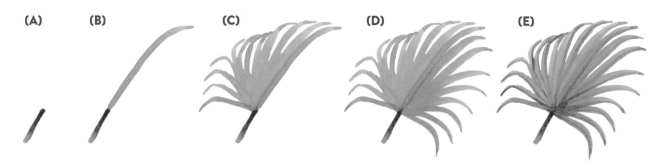

Day 25: CALADIUM

This incredible plant is a sight to see with its hot-pink body and green papery leaves. I always love a plant that can add a pop of color to its environment, even if it doesn't have a floral component, and the caladium does not disappoint. The caladium leaf is shaped like an arrowhead or heart; its wavy edges give it a perky personality. Here, you'll paint the Florida Sweetheart caladium, which has hot-pink leaves that are lined with green and fade into whites. Take note: The wet-on-wet technique will be our friend here.

What You Need

Watercolor Tool Kit (page 14)

Techniques

Wet on wet (page 32)
S curve (page 31)

Colors

Permanent rose (1)
Viridian hue (2)
Opaque white (3)

1 2 3

1. Using your size 4 brush and permanent rose, paint the left side of your caladium leaf by creating half a loose heart with wavy edges. Make sure your edges are wet and pigmented, then quickly line the edges with viridian hue to immediately blend the color **(A)**. If your permanent rose layer happens to dry, simply add a layer of water on top of the layer that is already on the paper, then be ready to paint wet on wet with viridian hue.

2. Repeat step 1 to paint the right side of the leaf **(B)**. Let the layers of paint dry.

3. Using your size 0 brush and opaque white, paint a loose C curve for the midrib down the center of the leaf. Start the midrib right under where the viridian hue has blended into the permanent rose and extend the midrib to the tip of the leaf. Paint a small upside-down triangle at the top of your midrib **(C)**.

4. To create the veins of the left side of the leaf, begin painting loose S-curved lines, lifting your brush and ending the curves where the green section of the leaf begins. Start by adding diagonal lines that branch from the midrib to the left arch of the leaf. As you move down the midrib, start angling the lines downward. At the end of each vein, paint a short, curved line to create a loose V shape with the long vein. Repeat to add veins on the right side of the leaf **(D)**. Let this layer dry.

5. Using the tip of your size 0 brush and opaque white, add loose clusters of small dots in the areas where the green meets pink **(E)**. These dots should be concentrated around the veins of the leaf. Make sure to add dots around the ends of each vein to make the veins look longer and give the illusion that they extend into the green trim. Let your leaf dry.

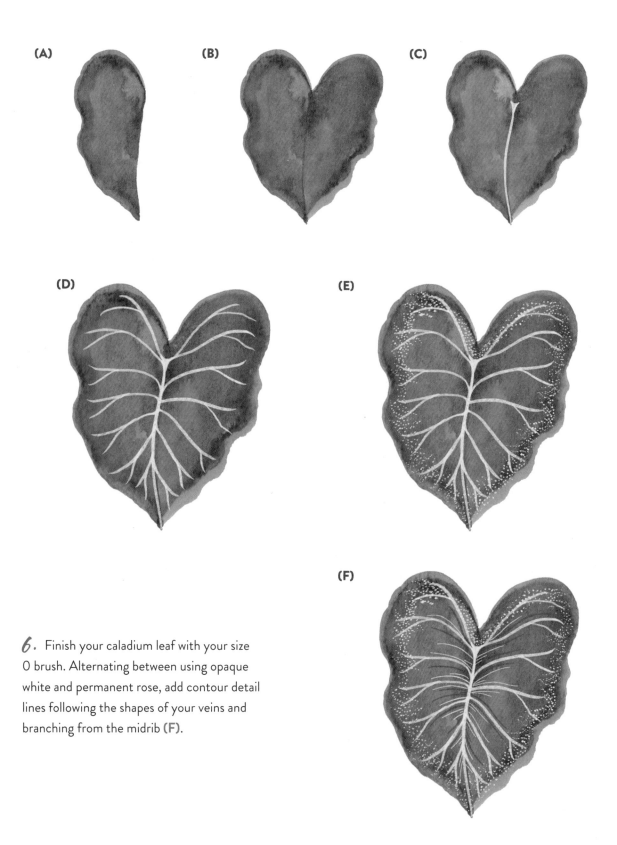

(A) **(B)** **(C)**

(D) **(E)**

6. Finish your caladium leaf with your size 0 brush. Alternating between using opaque white and permanent rose, add contour detail lines following the shapes of your veins and branching from the midrib **(F)**.

(F)

Day 26: TROPICAL LEAF ARRANGEMENT

Now that you've learned how to paint several tropical plants and may be in the mood for an island-inspired drink or a tan, let's create a fun tropical-leaf arrangement with the bright leaves of the monstera, fan palm, and caladium, and two bird-of-paradise flowers. The arrangement will be oriented vertically and centered on an 8 x 10-inch (20.3 x 25.4 cm) piece of watercolor paper.

What You Need

Watercolor Tool Kit (page 14)
Paper cutter or scissors

Techniques

S curve (page 31)
C curve (page 30)
Wet on wet (page 32)
Wet on dry (page 32)
Pulling paint (page 34)
Combination stroke (page 31)
Glazing (page 41)

Colors

Dark green (ivory black +
 viridian hue) (1)
Dark blue green (ivory black +
 viridian hue + ultramarine) (2)
Opaque white (3)
Permanent rose (4)
Viridian hue (5)
Hooker's green light (6)
Cadmium red pale hue (7)
Rose madder hue (8)
Ultramarine (9)

1. Measure and cut your paper into an 8 x 10-inch (20.3 x 25.4 cm) sheet. Orient the paper in portrait. With a ruler and pencil, measure and mark 1 inch (2.5 cm) from the edge of the paper. Make a small dot in the center of the paper so you know where to start painting.

2. Using the tutorial on page 102, sketch and paint the monstera leaf. Place the top left of the monstera leaf at the center dot, and point the leaf to the bottom right corner of the paper **(A)**. Let your monstera leaf dry.

3. Next, following the tutorial on page 112, paint a cluster of three caladium leaves, varying the size of each one. Place the cluster to the left of the monstera leaf and point their tips downward **(B)**. Let your caladium leaves dry.

4. Moving back up to above the monstera, paint a side-facing split bird-of-paradise leaf using the instructions on page 108. The leaf will curl over the top right section of the monstera. Then, paint a front-facing leaf angled toward the opposite direction **(C)**. The leaves will create a perfect frame for the two bird-of-paradise flowers. Let your leaves dry.

5. Using the tutorial on pages 106, paint two bird-of-paradise flowers **(D)**. Make sure to place one higher than the other and let them face opposite directions. Let your flowers dry.

6. Add two fan palms (page 110), one that hugs the left side of the arrangement and one that hugs the right side **(E)**. You can paint two front-facing fan palms, or one front facing and one side facing. Feel free to turn your paper horizontally to make them easier to paint. Let your fan palms dry.

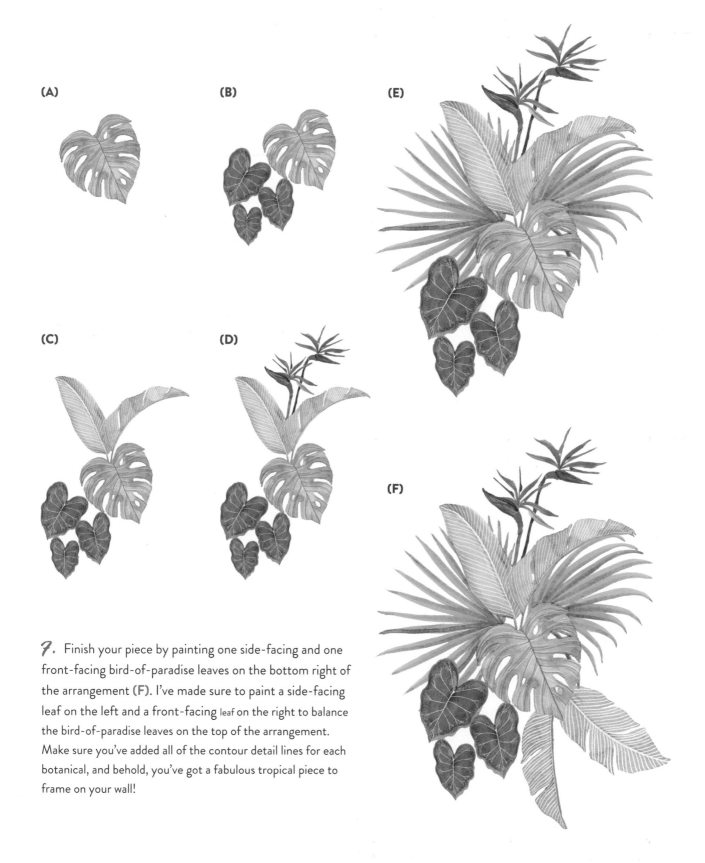

(A)

(B)

(C)

(D)

(E)

(F)

7. Finish your piece by painting one side-facing and one front-facing bird-of-paradise leaves on the bottom right of the arrangement **(F)**. I've made sure to paint a side-facing leaf on the left and a front-facing leaf on the right to balance the bird-of-paradise leaves on the top of the arrangement. Make sure you've added all of the contour detail lines for each botanical, and behold, you've got a fabulous tropical piece to frame on your wall!

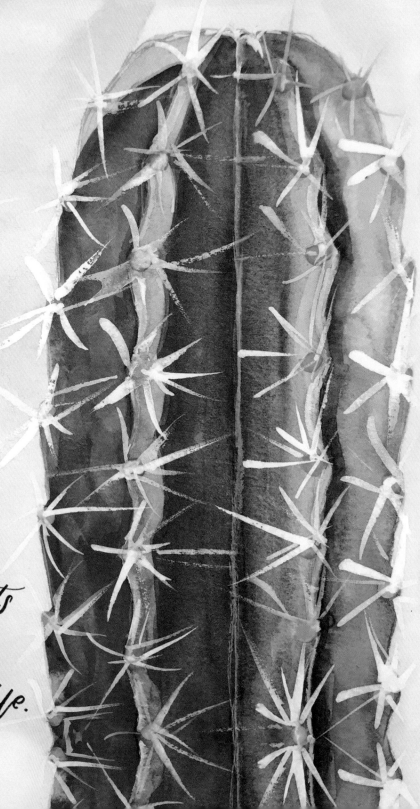

desert plants
make the
impossible
seem possible.

Desert Plants

Gone are the days when deserts were only depicted in old cowboy movies as barren landscapes full of tumbleweeds. With the current popularity of desert plants, the plant crowd and botanically obsessed have gone wild. The ability of these wonderful plants not only to survive but also to flourish beautifully in the intense heat and dry environment of the desert makes them extraordinary *and* attractive. In other words, I can't kill them as easily (though in reality I still kill them pretty easily). I've compiled some of my dearest prickly and fun desert plants for us to paint!

Day 27: PRICKLY PEAR

The prickly pear cactus has rounded upside-down teardrop-shaped pads that can grow abundantly. All cacti have areoles, the bumps out of which the cacti's needles (also known as spines), new pads, and flowers grow. The prickly pear cactus has evenly spaced, diagonally aligned areoles, and a few needles per areole. The flowers of the prickly pear are such a captivating accent to the already gorgeous plant, as they are full, bright blooms that range from red to yellow, deep pink, orange, and white. There are a few types of prickly pear cactus, but today you'll learn how to paint the *Opuntia humifusa* (also known as the eastern prickly pear) and its yellow flower.

What You Need

Watercolor Tool Kit (page 14)

Techniques

Wet on wet (page 32)
Wet on dry (page 32)

Colors

Sap green (1)
Blue green (ultramarine + viridian hue) (2)
Opaque white (3)

1 2 3

1. Using your size 4 brush and sap green, paint the first prickly pear cactus pad. The other pads of this cactus will grow off of this one. First, using the full side of your brush, create an upside-down, boxy teardrop shape, with a blunt bottom edge. While the sap green paint is still wet, line the sides and bottom with blue green to add shading **(A)**. Wait for this layer of paint to dry.

2. Next, repeat step 1 and paint two slightly smaller pads on top of the first, making sure to work quickly with the wet-on-wet technique **(B)**.

3. Following the same steps, paint five more smaller and narrower pads. Add two on top of the left pad that you painted in step 2 and three on the right pad **(C)**. Make sure to keep the bottoms of the smaller pads significantly narrower than the tops so they don't look like hitchhiking thumbs sticking out of the pads below. Let all the layers dry.

4. Using your size 0 brush and blue-green paint, add dots in a diagonal pattern to represent the areoles from which the prickly pear's needles will emerge **(D)**. Look for the spaces in the previous rows to start your next rows of dots so that you are staggering and evenly spacing the areoles across the pads.

5. Using your size 0 brush and blue green, paint two thin needles starting from each dot, making sure to alternate directions **(E)**. Let the paint dry.

6. With white, paint small, wide U shapes that hug the bottom of each areole **(F)**.

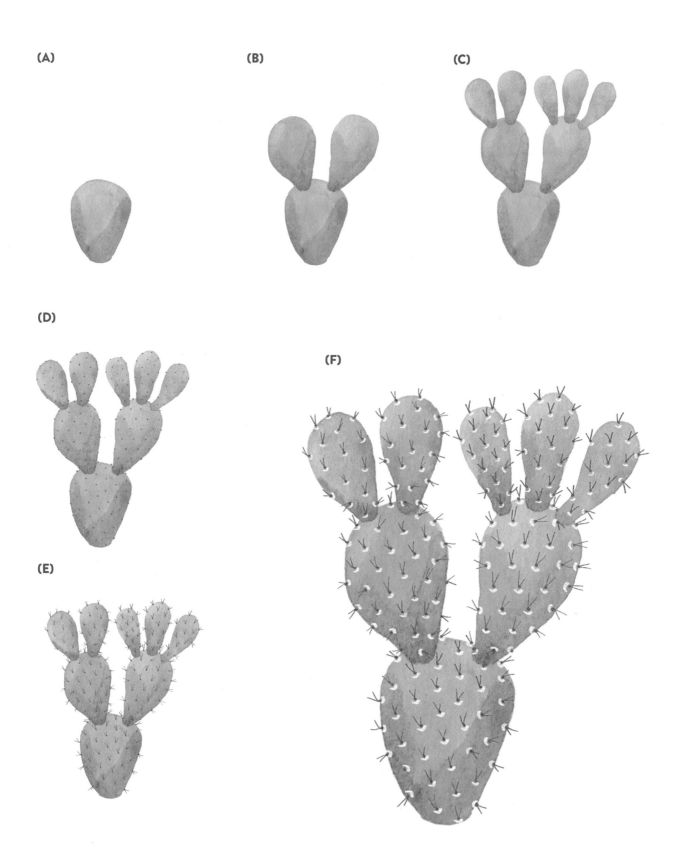

(A)

(B)

(C)

(D)

(E)

(F)

PROJECT: Prickly Pear Flower

The *Opuntia humifusa* flower has yellow petals with a red-orange starburst accent on their inner edges. At the center, there is a yellow-green pistil surrounded by yellow stamens and anthems. You'll paint a side view of the flower that allows you to see these details. The flower will sit on top of prickly pear pad, so start painting on the top half of your paper, just left of the center.

What You Need

Watercolor Tool Kit (page 14)

Techniques

Wet on dry (page 32)
Wet on wet (page 32)
Combination stroke (page 31)
Boomerang stroke (page 31)

Colors

Sap green (1)
Cadmium yellow hue (2)
Rose madder hue (3)

1 **2** **3**

1. Using your size 0 brush and sap green, paint a small, round circle for the pistil. When the pistil is dry, paint a thin cadmium yellow hue line down its center and two additional lines to split the circle into six sections **(A)**.

2. Using your size 4 brush and cadmium yellow, paint a diamond-shaped petal with rounded corners at the 12 o'clock position, leaving room between the bottom of the petal and the pistil. Use the side of your brush to paint the body of the petal and the tip to refine the edges. We'll fill this empty space with the stamens and anthems later. While the yellow paint is still wet, drop rose madder paint on the bottom the petal and blend it upward. Repeat this step to create the left petal **(B)**.

3. Working counterclockwise, with just cadmium yellow hue, paint two more petals using a combination stroke for each, moving from left to right **(C)**. These petals will be flatter and will show the outer side of the petals curling upward. Remember to leave space between the pistil and the petals.

4. In this next step, we'll paint the inner side of the petals that are barely in view. In the space between the bottom petals and the pistil, use a combo stroke with your cadmium yellow hue paint and blend in the rose madder hue immediately **(D)**. Leave a very small space between these strokes and the petals below to differentiate between the petal's outer and inner edges.

5. Finish this ring of petals by painting a petal to the right of the first one **(E)**. Let the paint dry.

6. For the second ring of petals, paint three additional petals, one each on the left, bottom, and right of the flower. Since the petals in this ring will all be peeling outward, use the boomerang stroke to loosely hug the sides of the first ring of petals. Switch to a size 0 brush and load it with cadmium yellow paint. Paint the anthems by adding dots to fill the negative space between the petals and pistils **(F)**. Let the layers of paint dry.

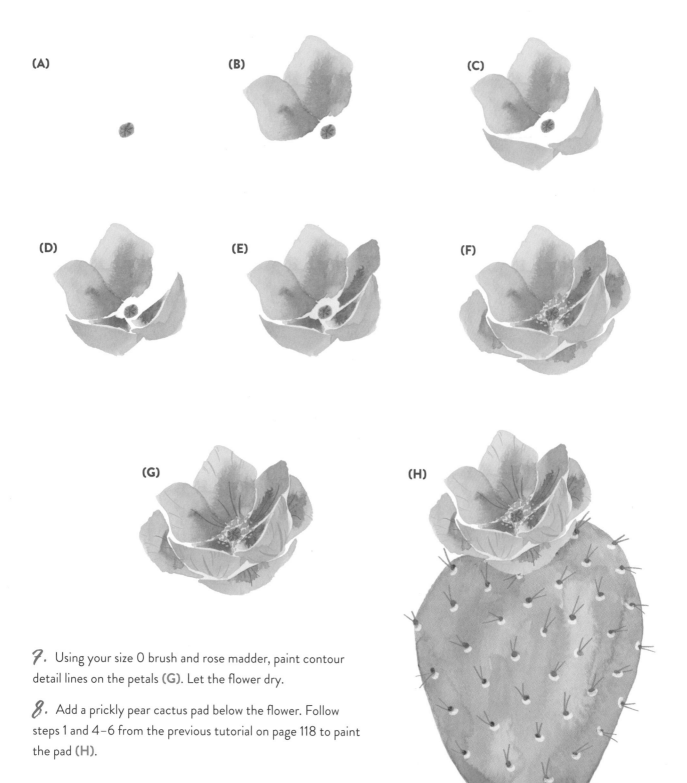

(A)

(B)

(C)

(D)

(E)

(F)

(G)

(H)

7. Using your size 0 brush and rose madder, paint contour detail lines on the petals **(G)**. Let the flower dry.

8. Add a prickly pear cactus pad below the flower. Follow steps 1 and 4–6 from the previous tutorial on page 118 to paint the pad **(H)**.

Day 28: SAGUARO CACTUS

A common symbol of the American Southwest and its deserts, the saguaro cactus is a magnificently large and old species that originated in Arizona, Mexico, and California. A saguaro can grow up to 40 feet (12.1 m) tall. It is considered an adult when it is 125 years old, but these plants live to the ripe old age of 200. This columnar or tall, cylinder-shaped cactus can grow up to 25 arms, also known as spears, but not until they're at least 75 years old. (Look, Ma! I grew my first arm!) Luckily, we're going to be able to paint a saguaro cactus faster than they actually grow. It will have three arms, ribs, and spines.

What You Need

Watercolor Tool Kit (page 14)

Techniques

Wet on wet (page 32)
Wet on dry (page 32)

Colors

Hooker's green light (1)
Dark green (ivory black + viridian hue) (2)
Opaque white (3)

1 2 3

1. With your size 4 brush and Hooker's green light, paint the main body of the saguaro cactus. Start with a straight brushstroke. Thicken the stroke and round the ends to create a craft-stick shape. While this is still wet, line the bottom right and right side of the body with dark green **(A)**. Let the paint dry.

2. Next, you will paint the arm that is sitting closest to us. Load your size 4 brush with Hooker's green light. Begin your brushstroke in the center of the body and curve the stroke to the left, out and upward, to create the arm, keeping the top part of the stroke close and parallel to the body. While the arm is still wet, line the lower half of the arm with dark green **(B)**.

3. Repeat step 2 to add a second arm on the left side of the body, under the first one **(C)**. Paint a third arm on the opposite side of the body **(D)**. Stagger the placement of the arms up and down the cactus body for a more natural look. Let these layers of paint dry.

4. Using your size 0 brush and dark green paint, begin painting thin, vertical contour lines along the body and arms of the cactus **(E)**. Make sure to follow the shape of the cactus's body and outline. Your lines should all meet at the center point of the top of the cactus and cactus arms. To do this, start at the center and paint a straight line. If you were to split the cactus body and arms in half, the contour lines would run through the center of both halves.

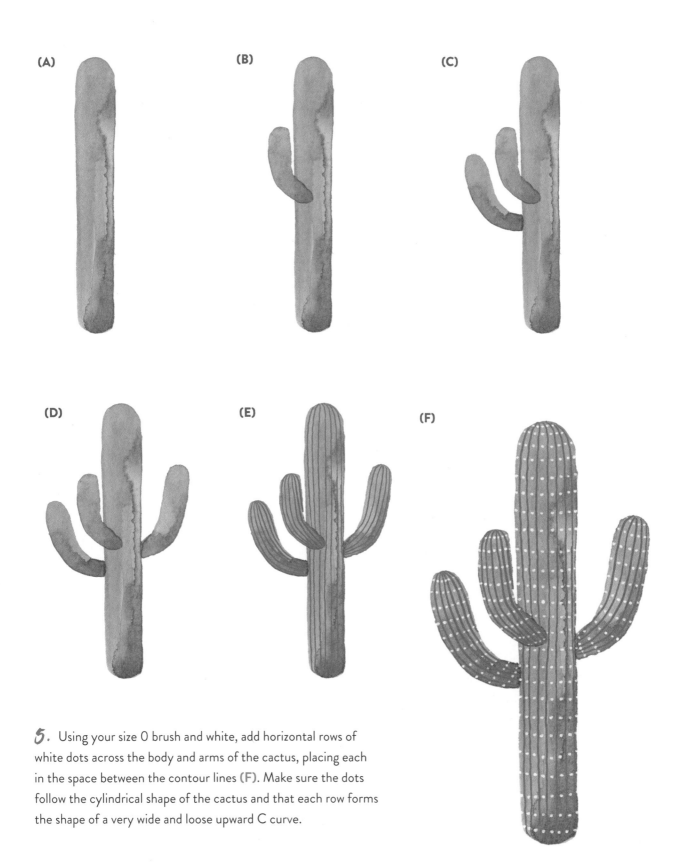

5. Using your size 0 brush and white, add horizontal rows of white dots across the body and arms of the cactus, placing each in the space between the contour lines **(F)**. Make sure the dots follow the cylindrical shape of the cactus and that each row forms the shape of a very wide and loose upward C curve.

Day 29: ECHEVERIA

Don't you just want to pinch a succulent's imaginary cheeks every time you see one? Simply the name gets me every time. I mean, are there any succulents that aren't cute? They're all darling! There are more than 25 plant families that include succulents, which are generally known as plants that can thrive on limited amounts of water because of their ability to store it in their leaves and roots. Today, you'll painting an *Echeveria* 'White Rose', which has pointed, pink-tipped leaves. Like the monstera (page 102), this guy does require some sketching, so grab your pencil and eraser.

What You Need

Watercolor Tool Kit (page 14)

Techniques

Wet on wet (page 32)
Glazing (page 41)
Wet on dry (page 32)

Colors

Hooker's green light (1)
Hooker's green dark (2)
Permanent rose (3)

1 2 3

1. Start with the center of the succulent. With your pencil, draw a vertical football shape and two rounded triangles that hug the left and right sides of the football **(A)**.

2. At the 12 o'clock position, sketch one pointed leaf. This leaf has the same shape of a typical pointed leaf, but only the top three-quarters is visible. On the opposite side of the center, sketch one smaller leaf with a tip that curves to the left **(B)**.

3. Sketch two more leaves that hug the left and right sides of the first leaf **(C)**. Point their tips upward.

4. Sketch three wider leaves with the tips pointing at about the 12 o'clock, 5 o'clock, and 7 o'clock positions **(D)**.

5. Next, you'll sketch three even larger leaves at the 3 o'clock, 6 o'clock, and 9 o'clock positions **(E)**.

6. Finish the sketch by drawing four leaves at the 1 o'clock, 4 o'clock, 7 o'clock, and 11 o'clock positions. These leaves should be the same size as the ones you drew in step 5. Erase your pencil lines to lighten them until they are just barely visible **(F)**. Now it's time to paint!

(A) **(B)** **(C)** **(D)** **(E)**

(F)

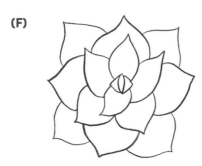

Note: In the next steps, the illustrations will not show any pencil lines.

7. Using your size 0 brush and Hooker's green light, paint the three center leaves **(G)**. Leave a tiny bit of space between the three pieces and avoid blending them completely together. We'll define each shape later.

8. With your size 4 brush, paint a layer of Hooker's green light on the top left leaf in the next layer of leaves. While this layer is still wet, use Hooker's green dark to paint a loose triangle in the center of the leaf. Then, with your size 0 brush and permanent rose paint, line the tip of the leaf, blending the color downward along the edge of the leaf **(H)**.

(G) **(H)**

9. Repeat step 8 to paint the rest of your leaves **(I)**. Make sure to leave a little bit of negative space between each leaf to avoid turning all the leaves into a big blob. After you've finished painting, let the paint dry.

10. Darken the areas that you painted with Hooker's green dark by glazing another layer of Hooker's green dark paint over it. This is also your chance to fill in the negative spaces you may have left after completing the

(I)

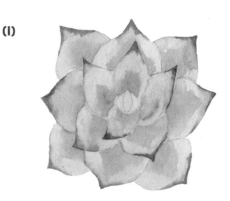

previous steps. Let your layers dry and then switch to your size 0 brush. With Hooker's green dark, outline the center of the succulent as well as any leaves that need additional definition **(J)**.

(J)

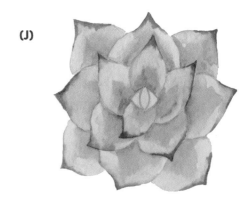

11. Using your size 0 brush and Hooker's green dark, paint contour detail lines that extend from the bottom of each leaf. Add shorter contour detail lines starting from the tips of your leaves using permanent rose **(K)**.

(K)

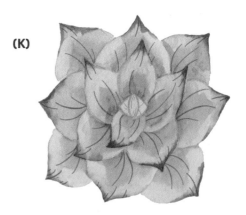

Day 30: ALOE VERA

Though it is from the succulent family, the aloe vera plant commonly grows in tropical environments all around the world. It's a plant with many benefits. On top of being a great sunburn soother, topical healer, and a hydrating drink, the plant also makes a pretty darn cute houseplant. It has wild teeth-lined arms and white spots. It grows inward and upward and is considered stemless, sitting directly on the ground or in a sweet pot. Here, you'll build the aloe vera plant from outside in and bottom up, with the outer leaves hugging the inner leaves. To differentiate between the inner part of the leaf and the outer part and to add teeth, you'll use the glazing technique.

What You Need

Watercolor Tool Kit (page 14)

Techniques

S curve (page 31)

Combination stroke (page 31)

Glazing (page 41)

Wet on dry (page 32)

Colors

Hooker's green dark (1)

Dark green (ivory black + viridian hue) (2)

Opaque white (3)

1 2 3

1. Using your size 4 brush and Hooker's green dark, paint the first leaf using an S-shaped combination stroke **(A)**.

(A)

2. Add a leaf to the left side of the plant by painting an S-shaped combination stroke in the opposite direction, moving from right to left **(B)**. This base of this leaf should sit right inside the first leaf.

(B)

3. Repeat steps 1 and 2 to add the next two leaves **(C)**. These two leaves will sit inside the first two, creating a V shape. Have fun with giving your aloe leaves some character by making the curves in some leaves more pronounced than others.

(C)

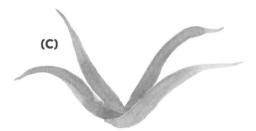

(D)

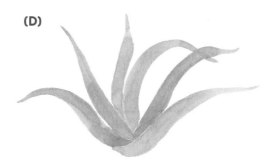

(E)

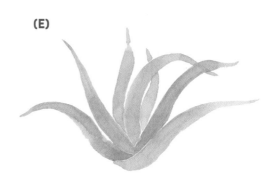

(F)

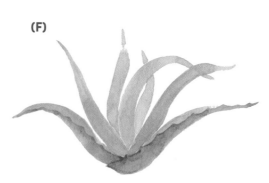

(G)

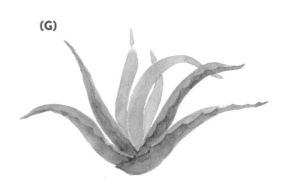

(H)

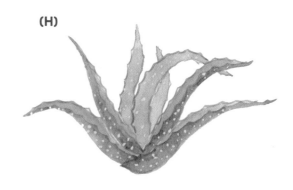

4. Repeat steps 1 and 2 to add the next layer of leaves **(D)**. These leaves should stand vertically. Don't be afraid to overlap the ends of these leaves with the ends of the leaves below. Later, you'll add layers of details to differentiate each leaf.

5. Fill in any open spaces with additional leaves **(E)**. In this example, I added one more leaf to the center. Let all the leaf layers dry.

6. Next, you will use glazing to add teeth and details to differentiate the inner and outer sides of the leaf. Using your size 0 brush and dark green, paint a scalloped brushstroke (think waves in the ocean), starting from the base of the left leaf and ending at its tip. Glaze down the rest of the leaf with your paint. Start at the base of the leaf, line the top edge of the base with dark green, and glaze the entire base with paint. As you move up the leaf, gradually use less paint to show more of the previous layer of paint. Repeat this step to add a scalloped brushstroke on the right leaf **(F)**.

7. Repeat step 6 to paint the outer side of the next two leaves **(G)**. Let dry.

8. For the last three leaves, imagine that the inside of the leaf is facing us. To create this, simply line the edges of the leaves with a scalloped pattern. Do the same for the top sides of the bottom four leaves. With your size 0 brush and white, add dots to the outer sides of the leaves. Cluster more dots at the base of each leaf. Add a few white dots to the inner sides of the leaf as well, but place them more sporadically than the dots on the outer sides of the leaf **(H)**.

SEE?
I TOLD YOU YOU
COULD DO IT.

- YOUR FUTURE SELF

You Did It!

Hey. Hey you. Yes, I'm talking to you! You did it! You completed all of these painting tutorials and projects, and you survived! It's time to celebrate and look back at the hard work that you've put into your watercolor journey. Whether you've participated in the 30-day challenge or not, take a glance at your paintings when you first started this book. Notice anything in particular? Do you see your progress, your improvement, and your personal artistic adventure? There's a bigger story there than you think. What was happening in your life at the time? What were you feeling at the start and the end of the day you painted the gerbera daisy? I bet there's a lot to be proud of, so please accept my heartfelt high five in congratulating you for being absolutely amazing. You deserve it.

What I'm also hoping is that you've built a habit of setting aside time daily, weekly, or monthly to be creative for you and, in many ways, for those around you! I have no doubt that you've inspired your tribe to dive into something they've maybe been hesitant about, didn't feel like they'd be good enough at, or didn't have time for. Here's your chance to encourage those on their own voyage to invest in themselves as you have, and just do the thing that they're afraid to do.

If you have participated on social media in the 30-day challenge, I encourage you to root others on and engage in the community that is at your fingertips, if you haven't already, that is! Tell someone on the daily that they're doing great, because kindness never goes out of style.

Now, my final challenge for you is to continue your odyssey in creating, painting, and looking for inspiration in your everyday life. You've come a long way, so there is no stopping you now!

As for me, you know where to find me. I'd love for you to join me on future adventures. Thank you for spending time with me. It's truly been an honor.

All the best,
Eunice

Resources

You've got a lot of watercolor supplies to choose from, so here's a list of some of my recommended products and where you can buy them.

WATERCOLOR TUBE AND PAN PAINTS

Artist's Loft (michaels.com)
Winsor & Newton Cotman Watercolors (winsornewton.com)
Daniel Smith Watercolors (danielsmith.com)
Reeves Watercolours (myreeves.com)

LIQUID WATERCOLORS

Royal Talens (royaltalens.com)
Dr. Ph. Martin's (docmartins.com)

JAPANESE WATERCOLORS

MozArt Supplies (usashop.mozartsupplies.com)
Kuretake (kuretake.co.jp/en)
Yasutomo (yasutomo.com)

WATERCOLOR BRUSHES

Princeton Artist Brush Co. (princetonbrush.com)
Winsor & Newton (winsornewton.com)

WATERCOLOR PAPER

Legion Paper (legionpaper.com)
Arches Paper (arches-papers.com)
Canson (en.canson.com)
Strathmore (strathmoreartist.com)

WHERE CAN I BUY ALL OF THESE THINGS?

Dick Blick Art Materials (dickblick.com)
Michaels (michaels.com)
Hobby Lobby (hobbylobby.com)
Art Supply Warehouse (artsupplywarehouse.com)
MozART Supplies (usashop.mozartsupplies.com)
TWSBI (twsbi.com)
JetPens (jetpens.com)
Amazon (amazon.com)

WATERCOLOR BOOKS I LOVE

Dean, Peggy. *Botanical Line Drawing: 200 Step-by-Step Flowers, Leaves, Cacti, Succulents, and Other Items Found in Nature.* New York: Watson-Guptill, 2019.

———. *Peggy Dean's Guide to Nature Drawing and Watercolor: Learn to Sketch, Ink, and Paint Flowers, Plants, Trees, and Animals.* New York: Watson-Guptill, 2019.

Koch, Alli. *Florals by Hand: How to Draw and Design Modern Floral Projects.*
Bend, OR: Paige Tate & Co., 2017.

———. *How to Draw Modern Florals: An Introduction to the Art of Flowers, Cacti, and More.*
Bend, OR: Paige Tate & Co., 2017.

Park, Jess. *Watercolor Lettering: A Step-by-Step Workbook for Painting Embellished Scripts and Beautiful Art.*
Berkeley, CA: Ulysses Press, 2018.

Rainey, Jenna. *Everyday Watercolor: Learn to Paint Watercolor in 30 Days.* New York: Watson-Guptill, 2017.

———. *Everyday Watercolor Flowers: A Modern Guide to Painting Blooms, Leaves, and Stems Step by Step.* New York: Watson-Guptill, 2019.

Smit, Irene, and Astrid van der Hulst. *50 Ways to Draw Your Beautiful Ordinary Life: Practical Lessons in Pencil and Paper.* New York: Workman Publishing, 2018.

Acknowledgments

Just a few years ago, I was sitting in my office wondering what my creative purpose was in this God-given life. I knew it had something to do with color, creativity, and people, so to be here today is quite an incredible moment. This is all due to the kindness, encouragement, and faith of the following individuals.

Kevin, my darling husband, you are the force behind all that I do. Beyond the thoughtful reminders to follow my dreams, the arguments against my doubts, and the many moments when you know me better than I know myself were also the infinite number of meals cooked, time sacrificed, and constant dedication to making me happy. I love you!

Mommy and Daddy, thank you for teaching me the definition of hard work through example and for the gifts of perseverance, discipline, and love. Mommy, thank you for teaching me that art is a universal language. Daddy, thank you for supporting all of my curiosities. I love you both.

Mom, Dad, and Brian, thank you for your unending support, for taking me in as your own, for believing in me, for your legal counsel, and for all the wine to make this and many more endeavors possible!

My best friends and life consultants, Bertie and Sunny, thank you for learning every process with me and for the daily encouragement to get me to the next crazy thing I want to pursue. I'm so grateful for all of your thoughtful responses to "What do you think about this?" and your love and care beyond friendship. Love you, Jie and Kaka.

Elysia Liang, my editor, thank you for choosing me, guiding me, and translating what came out of my brain to make this book happen! You are a creativity angel sent from the book heavens! Also to thank is the village of people who made this book possible, specifically: Jaime Chan, Gina Bonanno, and Christopher Bain.

To the online art community from which I've had the pleasure of learning, through which I built new friendships, and that has supported me as Electric Eunice throughout my journey, thank you! You all allowed me to grow as an artist and to be my crazy self.

And finally, to our sweet little baby, whom, while writing this book, we had yet to meet, but the anticipation was real and you've been on this journey as much as I have. Thank you for filling my daydreams, for the little reminders that you're with me through little kicks and hiccups in my womb during my late-night writing. Now that you're here, you're more than anything we could have imagined. You are our world, we know you're destined for greatness, and I can't wait to make you as proud as your mommy. We love you, little one!

Index

About the Author

*E*unice Sun is the self-taught watercolor and lettering artist behind Electric Eunice. Finding inspiration in her everyday life, Eunice loves to create to encourage relaxation, positivity, and laugh-out-loud moments. Beyond designing, she cultivates most of her energy and joy from being around others. Eunice has a passion for igniting the creative fire within individuals and teaches watercolor illustration and hand-lettering workshops. With her background in business and marketing, she strives to merge her self-taught talent for art by relating and connecting with her students using techniques and a love language that says, "No matter what your background is, you, too, can do this!"

She is known for her loud laugh, love for painting houseplants, and being every girl's BFF. You can find more about her at electriceunice.com and about her everyday shenanigans on Instagram (@electriceunice). She is based in Orange County, California, with her husband, senior citizen corgi mix, and their newest addition to the family—a little human baby.